T0182430

SELF-KNOWLEDGE

IN 40 IMAGES

Published in 2023 by The School of Life
First published in the USA in 2023
930 High Road, London, N12 9RT

Copyright © The School of Life 2023

Design @marciamihotichstudio
Printed in Lithuania by Balto Print

A proportion of this book has appeared online at
www.theschooloflife.com/articles

Every effort has been made to contact the copyright holders of the
material reproduced in this book. If any have been inadvertently
overlooked, the publisher will be pleased to make restitution at
the earliest opportunity.

The School of Life publishes a range of books on essential topics
in psychological and emotional life, including relationships,
parenting, friendship, careers and fulfilment. The aim is always
to help us to understand ourselves better – and thereby to grow
calmer, less confused and more purposeful. Discover our full
range of titles, including books for children, here:
www.theschooloflife.com/books

The School of Life also offers a comprehensive therapy service,
which complements, and draws upon, our published works:
www.theschooloflife.com/therapy

ISBN 978-1-915087-42-3

10 9 8 7 6 5 4 3 2 1

MIX
Paper | Supporting
responsible forestry
FSC® C107574

Cover: Markku Lähdesmäki, *Untitled*
(detail), from the 'Avanto - Hole in the
Ice' series, 2015. © Markku Lähdesmäki
(www.markkuphoto.com)

SELF-KNOWLEDGE
IN 40 IMAGES

The School of Life

CONTENTS

INTRODUCTION

One of the more peculiar aspects of the way we are built is that a sound understanding of ourselves greatly postdates our arrival on the earth. We will have been around a long while before we can explain in any depth 'who we are' (it's even a good couple of years before we can say our own name).

At the start, we manoeuvre without self-focused insight; we're alive, crawling about, making odd sounds, dribbling, but we don't have any ability to look within and make sense of our nature, what has happened to us or the context we have been born into. Childhood has things in common with being in a dream. It is a long time until we wake up and are – as it were – introduced more fully to ourselves.

When we say of someone that they appear to know themselves well, we're ultimately pointing to what feels like their good grasp of their emotional functioning. They know why they might be angry at a given point, what makes them proud, what brings them pleasure, why they are driven to act as they do. They can track the relationship between their states of mind and their levels of tiredness or stress; they have their finger on their mental frailties and on the relationship between their behaviours and their intentions – all of which makes them feel safe and rewarding to be around.

Conversely, when we're with a person who feels 'out of touch' with themselves, what they claim to be feeling doesn't tally with what we can observe them doing: they aren't able to warn us of their antics, they swerve erratically in their choices, they seem an unreliable narrator of their own story; they can be a trial.

The difficulty with pursuing self-knowledge is that we cannot just open up a hatch in our minds and step inside for a look. There is no stable 'I' to walk around and take the measure of. Asking ourselves too directly 'who we are' freezes the mind. We need to catch ourselves obliquely and in passing. We may have to wait until the more purposeful, censorious, day-to-day self is distracted or asleep (which is why twilight states can be optimal for gathering insights). We must assemble ourselves from clues; the process has things in common with archaeology – or detective work.

And yet if it is of value, it is because only on the basis of sound self-knowledge can we fulfil our potential: locate the right partner, choose a career that will work for us, build up trusting relationships, defeat our neurotic impulses and identify what we should spend our time and money on.

What follows is a sequence of images to tempt us to undertake, and accompany us on, a journey of self-exploration. The structure is deliberately loose, so as to encourage reflection and free association. It is in the gaps that we may find interesting pieces of ourselves.

Our societies surround us with suggestions of how we might determine success: according to how much money we have made, how many friends we have, how many countries we have visited. Here the implication is that the primary measure lies a great deal closer to home, in how well we have come to know ourselves – because a life of self-awareness is simultaneously a life of maximal calm, enjoyment and love. We are invited to take a look at this small museum of self-knowledge to catch a glimpse of our fugitive reflection in the disparate images of others.

A GROUP OF AMERICANS in southern Florida are having breakfast in what looks like a nondescript motel: bacon, hash browns, scrambled eggs, toast and orange juice. An incongruously ordinary beginning to one of humanity's greatest adventures. A few hours later, three of the men would be strapped into position beneath 770,000 litres of kerosene and over 1.2 million litres of liquid oxygen at the start of our species' first crewed look around our nearest galactic neighbour.

The chief problem with space exploration is its stupendous expense. The Apollo 11 mission cost approximately $355 million. Even the cheapest foray outside the planet will – for the foreseeable future – remain outside the reach of all but the most privileged minority. Not one of the 100 billion stars in our Milky Way will be for us to tour physically.

And yet, to an extent we seldom engage with or draw proper pleasure or excitement from, a mission no less complex or mysterious awaits us closer to home: the 86 billion nerve cells of our own minds. The journey is technically a great deal easier. We don't require explosives or command modules. We don't even need an MRI machine. We could probably manage with a pad and paper, a quiet room and an engaged and curious consciousness; it may also help to have a friend to jog the mind towards clarity. Or a good book.

To continue with the metaphor, psychological travellers are able to map not the craters and gullies of the Moon, but the pulses, visions, quirks and storms of their elusive centres of consciousness. We can survey the patterns of our moods, the distinctive memories that surge within us and the voices we hear in our own minds – and the prize of such peregrinations can be greater orientation, clarity and a sense of aliveness.

Our mission might last for the rest of our lives. Yet by the end, if we are fortunate and somewhat canny, we will have understood a little better where we came from and what made us who we have been.

Without observable noise or bother, we'll have been not only alive, but conscious of what our journey meant.

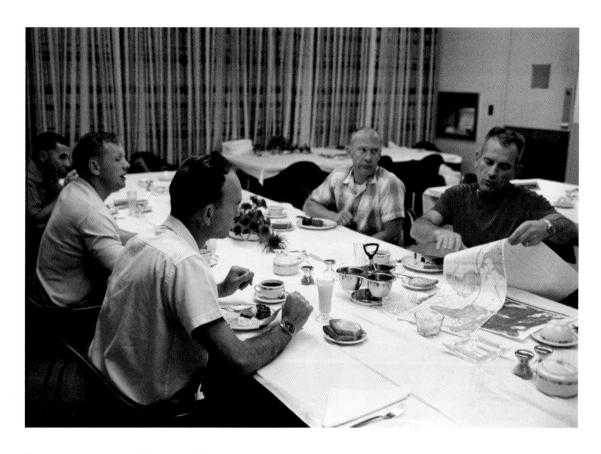

The pre-launch breakfast, Apollo 11 mission,
Cape Canaveral, Florida, 16th July 1969

ONE OF THE GREAT PARADOXES of the way our minds operate is that they both want to know more about themselves and simultaneously don't want to know much at all. The mind is an ambivalent organ, uneasily poised between an intense wish to acquire knowledge of itself and an equally avid desire to deny its most crucial truths.

Insofar as we'd rather remain in the dark, we are motivated by a hope not to have to suffer. Every day, the mind is confronted by bits of information that would, were these to be fully acknowledged, be highly distressing: perhaps we are beginning to sense that our partner is selfish and intolerably self-absorbed, but so much hope has already been invested here and a child is on the way ... Or a friend has done us wrong, and we should be annoyed, but how to complain about someone who is otherwise so kind? Or we are drawn to people of our own gender, but we know our family wouldn't be accepting ... Or time is passing and we are no longer so young ...

Around such troublesome insights, the mind engages its native genius for eliding full contact with the truth – for not quite taking on board what it at some level already knows. It will, for example, ensure that we are rarely left alone. It will throw us into work. It will addict us to exercise lest stillness give reality a chance to be felt.

But there is always a long-term cost to not knowing. We lose confidence, we grow irritable, we develop anxieties and compulsions. The waters of the truth start to press with ever greater insistence up against the dam of willed ignorance.

We should honour self-knowledge from a sense that not knowing will always eventually bring with it unbearable and unnecessary costs. We have to understand where we are sad, lustful or hurt in order eventually to be able to feel forgiving, passionate and authentic. We need to untangle our evasions – because lies inevitably prove too psychologically expensive to bear.

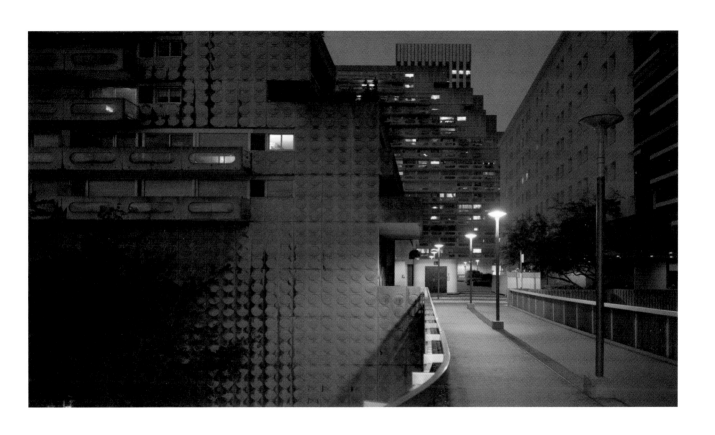

Rémy Soubanère, *Untitled*, from the 'Alphaville:
Paris suburbs at night' series, 2015–2018

WE KNOW THAT OUR STRESSED MOMENTS can result in hunched shoulders. Or that our stomach might not be so calm shortly before an important speech. But it remains surprising and humbling to what extent our psychological pains and fears inscribe themselves on our bodies and won't allow themselves to be forgotten – even if they don't utter clear cries of pain either.

We may have lost sight of how under-confident we are, but our backs continue to bear witness to our submission: our vertebrae are forever angled downwards in a stoop, our head is never quite as high as it might be. The body remembers that, years ago, there might have been a father who felt envious of our looks and our potential and led us to disappear into ourselves to evade his ire and his vindictiveness.

Or our digestive systems might be clogged and slow; every day might require hours hunched in the bathroom. The proximate cause may have to do with a lack of fibre or the operations of certain glands, but the true reason might lie with a controlling parent who terrified us with the consequences of evacuation and made withholding feel like the only safe option. We are both physically constipated and, more accurately but elusively, terrified of a caregiver's overbearing designs.

The difficulty is that medicine is not well set up to capture the nuances. It claims jurisdiction over the body while failing to explore its paradoxical connections with the travails of the mind. It prescribes extra magnesium, vitamin D or iodine without following the pain upstream towards suppressed reserves of sadness, rage or terror.

And at the same time, philosophy may ask us to consider our levels of happiness, but it seldom enquires into how our jaw muscles are, it doesn't probe into how we fiddle with our hands or what degrees of tension there are in the soles of our feet. Our bodies are an unvisited store for, and palimpsest of, the conflicts and griefs of the psyche. Our skin and our aches, our spinalis thoracis and our exhalations bear silent witness to long-distant regrets and humiliations. The diary of our mental health and self-awareness is daily to be found written in the record of our stools.

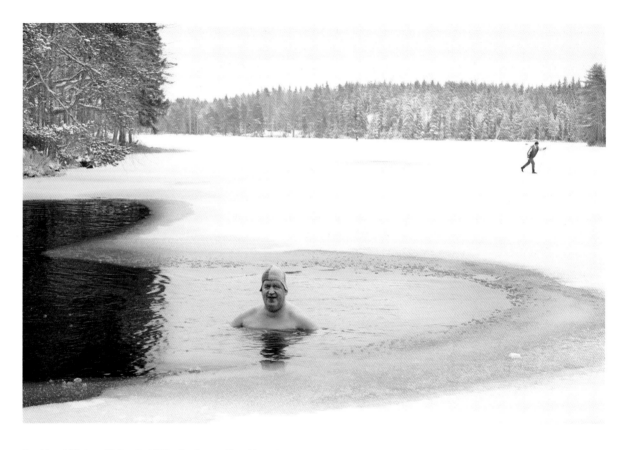

Markku Lähdesmäki, *Untitled*, from the 'Avanto –
Hole in the Ice' series, 2015

THE STUBBORN IMPORTANCE of psychology is never more acutely and painfully felt than when it comes to our inability to sleep. We may have wealth, acclaim and love – but if we cannot sleep properly, we may as well have nothing.

We live in a world unhelpfully inclined to pin the causes of everything on material factors. If we cannot get to or stay asleep, the problem must lie in how much fresh air is in the room, what the pillows are like or perhaps what we are eating.

But here, as so often, the real explanations are psychological rather than physical. Most of us can't sleep not because there is something wrong with our bodies, but because our minds are clogged with unthought thoughts. Insomnia is the mind's revenge for all the ideas we 'forgot' to have in the day. And we forgot to have them not because we were especially 'busy' – that's to invert cause and consequence. We got busy in order to forget them. And we did so because these thoughts were especially difficult to entertain.

They will have belonged to that large category of realisations that we'd so much prefer not to see bloom: about people who've hurt us and can't say sorry, people who didn't love us and wrecked our confidence, projects we lack the courage for, relationships we should leave …

In the day, enormous energy is employed to keep these thoughts at bay. At night, we let down our guard and, like restless dogs chained in the yard, the thoughts strain at the leash and howl to be heard.

Our thoughts don't care that we have a meeting tomorrow. There is a will to truth inside us that has the strength of a plant lifting up paving stones to come to the surface.

The cure for insomnia doesn't lie with a better ventilated room; it has to do with giving our thoughts airtime. This may be hard, and we will need help, but at least we'll have begun to diagnose the problem correctly. We don't have 'a sleep problem'; we have a self-knowledge problem.

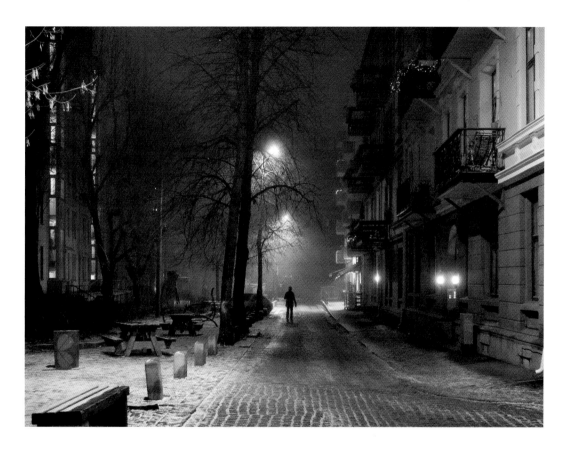

Tine Poppe, *Untitled*, from the 'Winter Solstice'
series, 2017

WHEN WE THINK OF AN 'ADDICT', certain stock images come to mind: a homeless person in the park sniffing glue, a gaunt figure with a heroin needle in their arm, a breakfast-time vodka drinker …

But such gothic characterisations mask what is in reality a far more universal and less overtly dramatic – though still pernicious – phenomenon. Addiction doesn't have anything to do with what one is addicted to: it can't be neatly circumscribed to those who rely on hard drugs or alcohol. In its essence, addiction simply means leaning on something – it could be anything – because it prevents particular ideas from coming into our minds. The addict relies on their chosen pursuit to block unwelcome emotions from storming the theatre of their consciousness.

The particular object of their addiction might be whisky or marijuana, but it could just as well be their mobile phone or ever more copious buckets of fried chicken. One can be addicted to talking to one's mother or cleaning cupboards, doing the accounts or tracking migrating birds.

What the addict fears above all is to be left alone, to have nothing to do other than to turn into themselves and to face unbearable sadness or regret, fear or longing.

The popular misunderstanding of what addiction is lets too many of us off the hook. It allows people to claim that they are merely going to the office again or checking the news, toning at the gym or catching up on football results.

Yet addicts are not evil or weak. They are first and foremost scared. The solution shouldn't, therefore, involve censorship and lectures, but rather love and reassurance. We should make moves to allow people to feel as safe as possible about opening more doors in their minds and confident that they can handle whatever might be skulking inside.

It is never really fried chicken or social-media updates we like anyway – we are just at a loss as to how to begin to reflect without terror on the course of our lives.

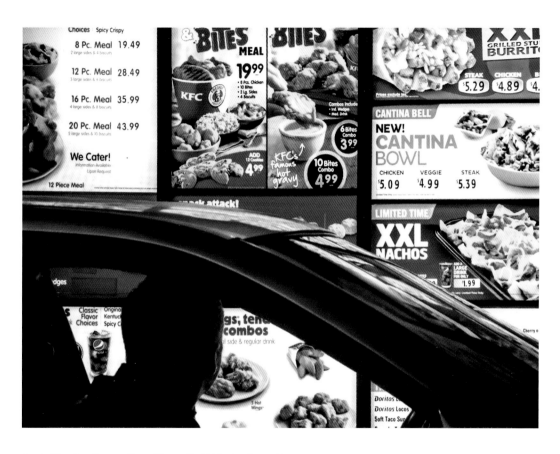

Isabella La Rocca González, *Untitled*, from the
'Fast Food' series, 2013

IT CAN SOUND ODD to suggest that someone might 'like' worrying. What could possibly be the benefit of messing up one's days being afraid of things that don't, strictly speaking, need to be of concern? Why might we, for example, worry all the time about catching a disease, looking ugly or failing in our career? Despite every kind of rational reassurance from onlookers, why might we be unable to stop panicking about messing up an exam, offending friends or having unknowingly hurt a child a decade ago?

It's a melancholy fact that worrying about certain themes may – in particular circumstances – feel to the deep mind like the lesser of two evils. On the one hand, we may indeed be wasting extraordinary amounts of time on topics that well-meaning friends insist should not concern us. But on the other, a defensive part of us can, somewhere in the recesses of consciousness, breathe a sigh of relief that we have once again prevented ourselves from thinking about other, still more potent and dangerous subjects.

The manic worrier is worried about something, just not what they consciously think they are worried about. Someone who worries constantly about their lungs and seeks repeated appointments with specialists who always draw a blank is, in reality, ill. Yet what is really wrong with them isn't connected to respiration; it's that many years ago they might have been parented by someone who preferred to shout at rather than love them; the real unspoken and unmasterable worry (and rage) is that the person who put them on this earth didn't care.

Or we might exchange the truth that someone sexually abused us long ago for an ongoing and unfounded worry that we have inappropriately seduced people in our adult lives. How much more preferable it can be to worry that we are guilty of having said something wrong on a date than to recall the specifics of an unfathomably cruel and appalling event that we might have been subjected to in our earliest years.

The mind is always trying to spare itself pain – and doing so at enormous cost to its long-term health. It's a measure of how badly some of us have suffered that being alarmed every day can feel like less of an ordeal than would a reckoning with the past.

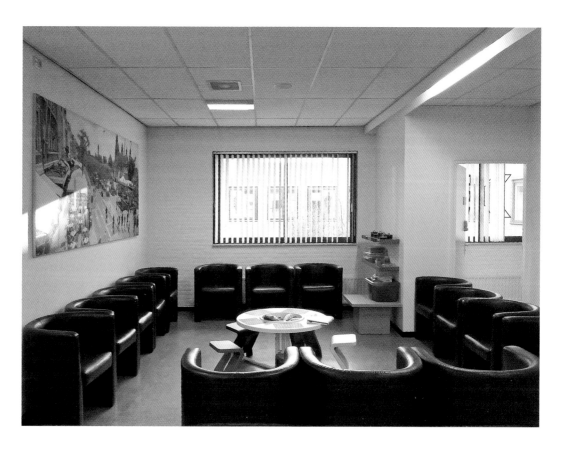

Guido Paulussen, *Untitled*, from the 'Medical
Waiting Rooms' series, 2017

IN CERTAIN MOODS, the founding principle of modern psychotherapy – that it is all to do with one's childhood – can sound especially irritating. Why should we be forever tied to things that happened infinitely long ago? One hardly ever sees one's parents now, or they might have died twenty years ago. And anyway, aren't genetics more important?

Nevertheless, the maddening idea refuses to go away as we'd love it to. There is too much – in the end – that keeps lending it credence. Our characters appear to be ineluctably and miserably determined by dynamics that unfolded within the family circle before our 15th birthday. Most of our strangest habits, deepest irrationalities and gravest errors are impossible to explain without reference to the quirks of our progenitors back in the old home.

We can accept well enough that we once learnt to speak an entire language around our families: tens of thousands of words, hundreds of declensions and a host of complex rules of syntax were all picked up while we played in the garden or drew sunflowers in the kitchen. It should – by extension – be no more implausible that we simultaneously learnt an entire emotional language (that is now as much part of our nature as our native tongue): a language about how to express love, what we can expect of men and women, the declensions of desire – and what the rules are around happiness.

The difficulty we face is that almost all families spend inordinate energy pretending that they are normal. We can expect to encounter a lot of denials and sentimentality if we start to probe too far into the official history. But the protests shouldn't rattle us; indeed they tend to prove we're on track. We should be unembarrassed about our search for the details of how our particular family – like all families – was, and has rendered us, *mad*.

We need to think about our families a lot – not necessarily because we like or miss them. It's the opposite; we need to reflect on them in order to get over them. It's when we fully understand what bits of our behaviour today are anchored in the grammar of the early years that we can start to learn a new, more liberating language better suited to our authentic intentions. The point of dwelling at length on our families isn't nostalgia; it's about moving on.

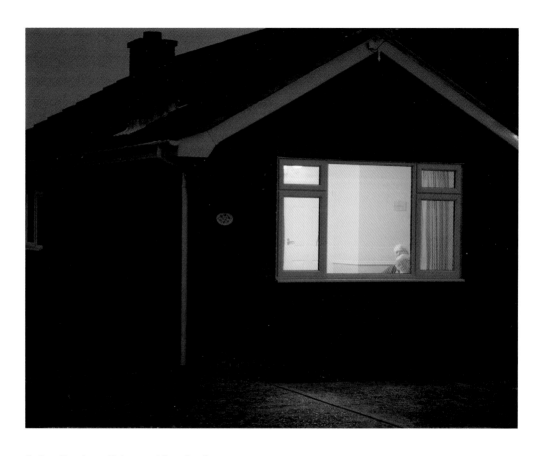

Nadav Kander, *Interruption I*, from
'The Parade' series, 2002

IF WE CONTINUE TO FIND it all too implausible that early childhood could have such a role to play in shaping our later adult selves, we should spend more time looking at, thinking about and hanging out with very small babies.

The immediate thing to notice is just how frighteningly vulnerable they are. They are utterly incapable of meeting the world with the necessary strength or canniness; they are entirely at the mercy of the prevailing environment. They are supplicants to the giants around them – who might not have undergone eighty years of careful training at the hands of a blend of Plato, the Buddha, Jesus and Freud. Babies are reliant not just for a few days (as newborn dolphins or horses are), but for year after long year. Almost all parents try to do their best, but seeing one of these unformed bundles in a hospital ward poised to enter another household, one can't help but be daunted and scared: what will this creature of infinite sensitivity and potential meet with?

If so many of us are compromised and unable to bring our potential to fruition, it should not be surprising. In the broken conditions of the world as it is, what chance is there of us being fed a milk of an appropriately wise and sustaining kind? We may not ourselves have been beaten or actively ignored, but much of our dawning sensitivity will have been subtly but firmly overlooked and stamped out of us. Our tiny hands never had the opportunity to unfold as they should. There might have been warmth and food, but people were probably shouting, doors were slamming, there may have been cries and hits. It was enough to break our minds.

Of course, everyone should – it seems – be allowed to have a child and to take it home and try to do their best by it. But what a frightening kind of liberty nevertheless and how many of us have been sacrificed on the altar of this impossible ideal ... How many of us would, in more bossy but careful societies, have been spared our particular beginnings?

Almost all babies leaving hospital have small tragedies waiting for them in their new homes. We need to understand what our own particular ones might have been and, when we're feeling strong, renew our efforts to spare others the pain and loneliness we have probably been through.

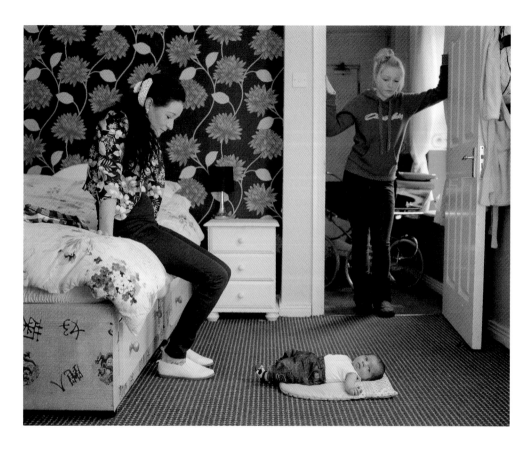

Doug DuBois, *Shauna, Patrick and Corey, Cobh, Ireland,* from 'My Last Day at Seventeen', 2012

WE MAY FEEL THAT it is a uniquely Western neurosis, especially one afflicting people who have spent too long in therapy, to go on about one's parents and their contribution to one's unhappiness – to be 25 or 62 and still turning over in one's mind (often while sobbing) how 'Mummy' or 'Daddy' have been responsible for spoiling one's relationships or ruining one's life.

But lest we be overly struck or appalled by this approach, we should keep in mind that every society, whatever its level of development, appears to entertain extremely elaborate and ongoing thoughts about its ancestors and their powerful impact on the lives of the living. From Cambodia to Peru, Papua New Guinea to Burkina Faso, the patterns are the same: one's parents or relatives die and one then has to handle their ghosts or spirits with immense care – because the dead are known to have powers to cause grave mischief. They may unleash guilt, they can destroy sex for us, they may put a curse on our ambitions at work, they can cause us insomnia or chronic stomach pains. Much time and energy therefore has to be spent managing their memories, which might involve bringing them presents, honouring them with cakes or songs – or, if all else fails and

their characters are too mean and too far gone, actively trying to drive them away into the netherworld.

In Madagascar, in the ceremony of Famadihana, every five to seven years the dead have to be unburied and are invited to a big party in the village, where their relatives sacrifice oxen and dance with their corpses above their heads – in the hope that these ever more mouldy cadavers will rest easily in the years to come.

Quite what one might have to do to keep an ancestor from ruining one's life may change from society to society, but the underlying feeling that one must try something is universal. One might have to disinter them and treat them to a dance, or one might need to lie on a couch and analyse their hold on one's psyche through free association. But the idea is fundamentally the same. The spirits of the past have the power to throttle the present. The headaches or the impotence, the paranoia or the bad marriage have to do with ghosts. Our ancestors are everywhere, doing unholy things – and the wise pay them enough attention to loosen their punitive grip and get on with their lives.

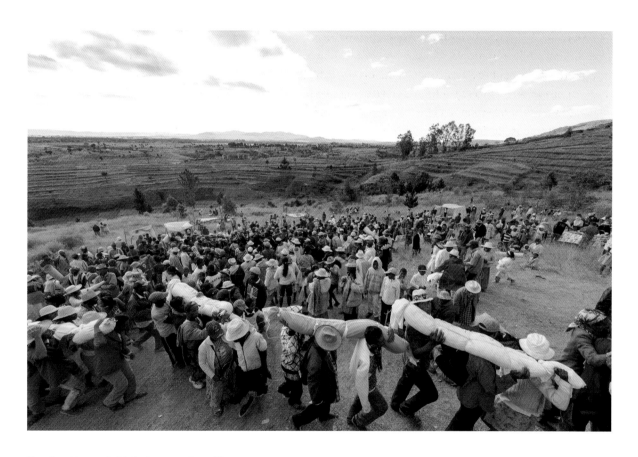

Margherita and Nick Burns, *Famadihana ceremony,*
Madagascar, 2015

THE PREMISE OF COMEDIANS is that they stand up on stage and stylishly tell us rude and shocking things about ourselves that are fundamentally true but normally warded off from our squeamish consciousness by fear, vanity and pride. We laugh gratefully in acknowledgement of certain painful yet necessary verities that have been rendered newly palatable to us, and escaped our defences, thanks to the genius of art.

We throw back our heads and implicitly admit that, yes, we really have been ridiculous, cheap, sensationalist and pompous. We truly are nothing but blockheads. And we are glad that someone has, at last, dared to tell us as much.

The reason why comics need to be especially clever (far cleverer than any psychologist) is that they are tasked with a double mission: they have to highlight a truth, and they have to succeed in not threatening people with its revelation. Jesters employed by the kings and queens of Europe understood this double challenge well enough; they knew that their monarchs needed to hear difficult ideas about themselves (something in these elevated and remote people craved to confront their imperfections and hear, for example, how counterproductive their anger was or how bad their judgement could be), but there was always a risk of triggering a burst of grandiosity or murderous paranoia if the needle went in too deep. As the Irish playwright George Bernard Shaw (1856–1950) knew: 'If you want to tell people the truth, make them laugh, otherwise they'll kill you.'

It's a strange but hopeful aspect of human nature that we have a capacity to hear how silly we are and relish the insights that good comedy has into follies about which we're normally unhelpfully stern; we want – at least sometimes, in our more relaxed moods – to learn and to grow.

When someone spots something ridiculous about us and gives us a cleverly funny nickname (Schopenhauer, Eeyore, Darth Vader, Little Miss Sunshine), we aren't usually automatically offended, as we might be. We can laugh because we know that something excessive and immature has been called out – and we are being given a chance to develop. Comics are at heart teachers who have found an especially good method for getting their lessons across (they tend to have learnt this from an early age, often as the offspring of violent and humourless parents). And their favourite subject of instruction is the same in every era and land: how to be less conceited, blind and mean; in other words, how urgently to become a bit less of a fool.

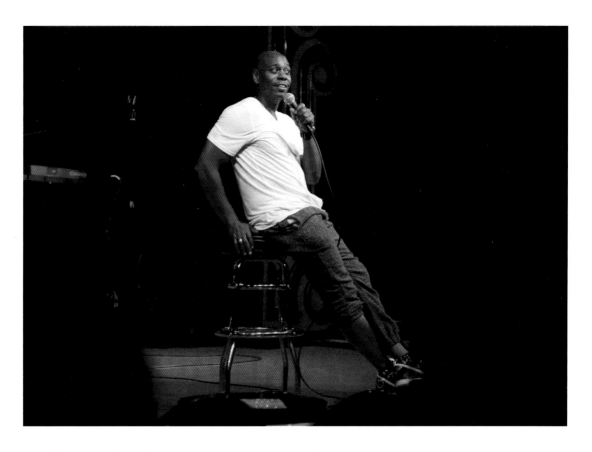

Comedian Dave Chappelle at The World Famous Comedy Store,
Sunset Boulevard, California, 2014

PART OF WHY IT IS SO HARD to understand ourselves is that people are constantly doing things to us that defy the common-sense view of how human beings might plausibly behave around people they claim to care about. We expect that those who carry the title of Mum or Dad or husband or wife would, unless they had very clear reasons to do otherwise, show us kindness. And yet the brutal reality (which we must take on board for our own sanity) is that humans are frequently beset by feelings that are so intolerable and difficult, they develop urges to pass them on to others in a version of emotional pass-the-parcel.

Put another way, humans can end up being cruel not for money or territory, but in the hope of alleviating their own sufferings by making someone near them suffer in their stead. Cruelty is at heart an attempt to make ourselves feel better by doing to someone else a version of what was done to us.

Amidst the seeming normality of family life, people will hence inject someone else (a spouse, a child) with a poison – an ill will, a contempt, a hostility – which they then deny ever having put into their bloodstream and which the victim themselves can't clearly detect, so invested are they in thinking well of those around them.

A mother might, for example, inject her daughter with a poison that 'says': 'Don't ever succeed in your life; it would make me feel too bad about myself.' Or a father will inject his son with poison whose meaning is: 'I want you to fail in your career to alleviate my sense of disappointment.' Or a spouse will inject their partner with a poison that carries the meaning: 'I will constantly but very subtly disrespect your intelligence and your sexuality to lessen the feelings of rage and powerlessness I experienced when I was little.'

Such injections wouldn't work if they were noticed, so enormous energy goes into the cover-up. It's debatable how much the injector even understands what they are up to; they are more 'driven' to act than they are cleanly aware of how or why they are doing so.

A big part of self-knowledge means realising that those we love and trust may have put some hugely damaging ideas inside of us that need to be identified and purged to help us attain the freedom and light-heartedness we crave.

Elise Corten, *Self-Portrait With Mother*, from the
'Warmer Than the Sun' series, 2019

SOME OF THE MOST PUZZLING and often worrying phenomena of psychological life are the incidents commonly known as 'breakdowns', in which people find themselves suddenly unable to carry out their normal duties – and fall silent, take to bed and cannot stop crying.

It can look mysterious from the outside, but what is almost always happening is an attempt to untie a lie that someone else has surreptitiously knotted into our lives. Beneath the breakdown, a long-repressed truth is trying to break through layers of deception. A person is unable to function 'normally' because 'normality' has grown riddled with something incoherent, mean and impossible. The breakdown is a logical bid for health and truth masquerading as an illness.

What has made us ill tends to be a variety of perverse injunctions under which those we trusted may have made us live, for example: *I'm ostensibly asking you to succeed – but I won't love you if you do*. Or: *You must fail – in order that I can bear my disappointments*. Or: *You must feel terrible about yourself – to shore up my sense of worth*. Or: *Worry all the time – so that I can be carefree*. Or: *You can never be happy – for it would make me too sad*.

We have probably been trying to make sense of these paradoxical messages for a long time, but now, rightly so, we can't take it any more. We are compelled to untangle the perverse position we have been placed in. Our illness acts as our conscience; it won't let up until we have figured out the truth; it can't tell us the truth by itself, but it is urging us to make the effort to find it out. The twitching, paranoia or despair are there to keep us honest. The illness's contract with us is: understand me, and I will leave you alone; ignore me, and I will upset normality to prevent you from deceiving yourself any longer. Our illness is the midwife of truth.

The fortunate ones among us manage to decode the riddle. We begin to get a sense of who may have aggressed us – and how odd and sad it is that they should have done so (not least because they might be our parent or our spouse). We have fallen ill because we have been victims of a cruelty that we needed the cover of 'madness' to be able to look at. We aren't really ill at all – we may be closer to sanity than we have ever dared to imagine.

Kurt Simonson, *Veranda (Swedish Light)*, from the
'A Thin Silence' series, 2011

WE NEVER GET TO SEE more clearly the havoc that a lack of truth and self-knowledge can wreak on the human psyche than when it comes to the abominable phenomenon of child abuse.

There is the obvious horror of the physical infraction itself. But there is also the equally catastrophic imposition of a lie. The child isn't merely violated; they are asked to forget or entirely misunderstand what has happened to them. The abuser scrambles the child's mind in order to escape censure. They force the child to believe a version of events wholly at odds with reality and in the process they destroy the child's ability to think (that is, to make distinctions and follow logic). The child is mesmerised into inverting values and identities; their mind is scrambled: 'awfulness' becomes 'a treat'. 'Horror' is 'fun'. 'Betrayal' is 'trust'. And 'callous' is 'kind'.

In the course of this inversion, the child tries to make sense of who is 'bad'. Someone must be, given that, as they intuit, something bad has happened. But it cannot be the adult; the big person is sure to have made it impossible to be thought of in such terms, after all the presents, the holidays and the little confidences and treats. In which case, there can only be one conclusion: it's the child who is appalling. To the burden of physical abuse is added the albatross of shame.

Even if the child realises what has happened, they tend to believe that they must somehow have deserved the treatment. The abuser may have been evil, but – they assume – there must have been something about them that would in some way merit heartlessness. Bad things surely chiefly happen to bad people.

The deceptions of mind we see in child abuse are not limited to situations of physical atrocity. They can be found in a range of other maltreatments that can be comparably hard to identify: situations where children are belittled, ignored or humiliated. An adult can do one thing to a child while insisting that they are doing another – in a way that wipes out the young person's mind and sense of worth.

We can see that recovering from trauma must, to a large extent, involve an enormous effort of the intellect: a new story has to be pieced together from substantially destroyed or waterlogged archives. We have to think our way out of trouble. We get better by growing sensitive to, and appropriately outraged by, falsities that others have devoted a lot of demented ingenuity to instilling in us.

Fabio Moscatelli, *Arriving-Somewhere_3*, from the
'Arriving Somewhere Not Here' series, 2013

EARLY ON IN EVERY LIFE, a child will look up and – implicitly – ask the world: 'Am I OK? Do I deserve goodwill and sympathy? Am I on track?'

And, most commonly, the person who first answers these questions is a parent. Perhaps this parent happens to be generous and sympathetic; they are warm and understanding of the challenges of being alive – in which case the child develops an easy conscience. In the years to come, they appraise themselves with benignancy; they don't continuously have to wonder whether they have a right to exist. They are comfortably on their own side.

But if the parent is more punitive, the picture grows darker: approval is always uncertain, there is a constant fear of being called arrogant or of being upbraided for something one hadn't thought about.

What's tricky is that consciences don't stay neatly identified with those who kick-started them. It's rare to find an adult who actively still wonders what their parents think. But we still wonder about our value in more general terms. It's just that we may, without noticing, have taken the question somewhere else – very often, to a particularly harsh modern figure of authority: media and social media.

To this pitiless arena, the self-doubting person now directs all their fears of unworthiness and panicked desire for reassurance. To a system set up to reward sadism and malice, they constantly raise their phones and implicitly ask: 'Do I deserve to exist? Am I OK? Am I beautiful or respectable enough?'

And, because social media is built on the troubles of the individual soul, the verdict is never a reliable yes. One is never done with cycles of fear and reassurance-seeking. Every time their spirits sink (which is often), the self-doubting sufferer picks up their phone and begs to know whether they have permission to go on.

If this might be us, we should grow curious about, and jealous of, people who are free. They are so because someone long ago settled the question of what they were worth, and the answer has seemed solid ever since. Social media is a roar in the next valley, not a mob in their own mind.

Learning from these calm souls won't just involve deleting a few apps. We will have to go further upstream, back to the baby self, whose alarmed enquiries we must quiet once and for all with ample doses of soothing and longed-for kindness.

Catherine Balet, from the 'Strangers
in the Light' series, 2009

WE DON'T NEED TO BE a German Renaissance prince to appreciate how satisfying genealogy can be. We seem to have an almost innate desire to understand where we have come from and to trace the complicated ways in which our family trees have wended their way, branch by branch, towards our own existence.

But if we're trying to find out who we are, then the answers given by the genealogical chart seem unable to provide us with more than a small, and arguably not the most penetrating, share of insights into our natures. It isn't by knowing the dates of birth of our third cousin or great-aunt that we can hope to go far into the essence of our identities.

In the end, the critical things we inherit from our families aren't lands or titles but emotions. What we actually need are genealogies of an emotional rather than a practical sort, ones that indicate who gifted what psychological 'issue' to whom. 'We' might, for example, be the result of the contempt we inherited from one parent and the detachment from the other. Moving up a layer, one parent might have inherited disregard from their father and adoration from their mother, while the other parent acquired neglect from their mother and seductiveness from their father.

Emotions combine and recombine in ever more distinctive alloys: timidity and absence can lead to passive aggression. Weakness and scorn can create depression. Neglect and rage might generate defiance.

It can be a great deal harder to assemble an emotional genealogy than a practical one. Relatives are typically invested in implying, contrary to the observable facts, that only love and kindness cascaded down the generations. We may have to fight subterfuge as well as forgetting.

In an ideal future, parents would be expected to unfurl – and talk through – their carefully collated emotional genealogies as soon as a child was ready. Offspring wouldn't have to spend thirty years and a fortune on therapy to tease out what their parents could, with a little insight and courage, have admitted to them in a few hours.

Our emotional genealogies would, in this perfect world, guide us through our central choices. Couples on a date might want to bring theirs along and discuss them over dessert. We wouldn't just have to guess that everyone was disturbed; we'd understand more about how and why they were so. There might be fewer poisoned emotional inheritances to be passed down and ruin succeeding generations.

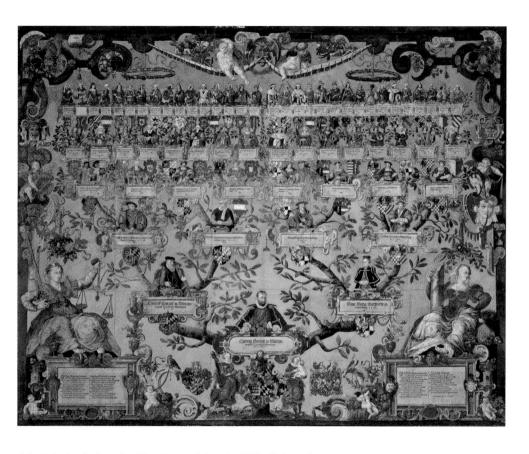

Jakob Lederlein, Family tree of Louis III, Duke of
Württemberg, 16th century

THERE IS SOMETIMES only so far we are able to go in understanding our minds without the help of a psychotherapist. We typically call one up when we're both in great pain and have ceased to make any sense of why. We might, for example, be worrying continuously about professional failure and humiliation; we might think obsessively that people are plotting our downfall and about the obliteration of our reputation. Friends might reassure us that reality was nowhere as dark as we feared – but our paranoid torment might be unceasing; we'd be searching our name online at all hours, waiting for the axe to fall.

The first thing a canny therapist would do is step back and wonder what might have made a successful life feel so dangerous and so threatening. We might claim we were worried about failure, but would it not be more accurate to say that something about our success was frightening us? What 'law' might we sense we were implicitly violating by being happy? And, conversely, whom might we be strangely trying to obey, or pay homage to, through being tormented and abject? In the course of many conversations, it might emerge that there was – in our background – a father who was unusually cruel and belittling. Not for him the pleasure of handing on his experience and his love to his child, only a desire to crush his offspring, in the vague hope – well known to bullies – that this torture might alleviate his own symptoms.

The therapist might observe that their client's paranoid feelings reached a particular pitch just as they were reaching the peak of their career, as if, by succeeding, the child was breaking the law instilled in them early on by an ill parent: thou shalt never rival me.

The proposed solution would lie in learning to notice this punitive dictate and to protest its injustice. Slowly the client would come to see that there was no incompatibility between succeeding and being safe, that the envious strangers they imagined everywhere were, in reality, echoes or shadows of a single malevolent paternal ghost who could be put to rest.

We can't expect an average friend to do such detective work for us. Nor can we be expected to notice the clues by ourselves – given how invested we often are in being dutiful. The answer lies in us – and we need a guide to unearth it. The therapist is a companion who takes us by the hand and travels with us into the underworld to identify and slay our devilishly well-concealed tyrannical monsters.

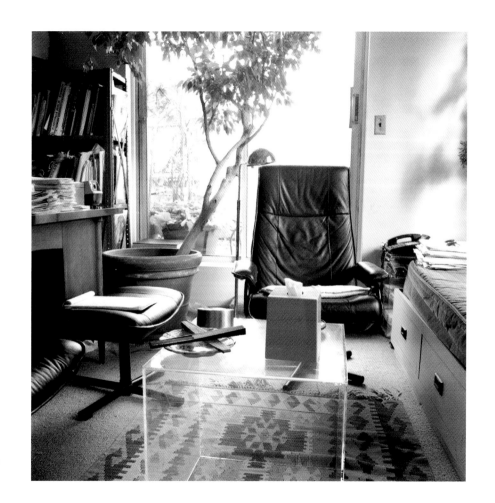

Saul Robbins, *Upper West Side*,
2008, from the 'Initial Intake'
series

IN THE EARLY 1920s, the Swiss psychologist Hermann Rorschach (1884–1922) made a remarkable discovery: the distinctive tenor of a person's mind could be revealed by asking them to look at smudges made by ink pressed between two sheets of paper and prompting them to free associate.

Rorschach noticed how different people's interpretations could be. Some people kept 'seeing' ghosts, others sweet rabbits; there were sightings of guns and flowers, vaginas and guillotines. What Rorschach grasped was that the analysis a client provided ultimately said more about them than about the pattern itself (which was by definition abstract and ambiguous). The inkblot test offered a glimpse into the patient's submerged desires and fears; it was a royal road into their unconscious.

A patient unknowingly terrified of authority might, for example, see weapons everywhere; someone who longed for maternal care might repeatedly see outstretched welcoming arms. Rorschach concluded that what we see in the inkblot is not the world but ourselves.

We don't – of course – only do this with inkblots; we do it chiefly in our own lives with the ambiguous behaviour of people around us. We constantly draw assumptions about them and their motives on the basis of unknown expectations and scripts created in childhood. Someone with bitter experience of rejection in childhood will 'see' signs of the end of their present relationships at every turn; another who was deemed unacceptable when small will be unable to imagine that others wouldn't laugh every time they left a room.

Projection tests reveal the extent to which what is already in our minds incites us to misread what is in front of our eyes. We see what we have been primed to see by misleading or one-sided experiences in our long and largely forgotten childhoods. Releasing ourselves from the grip of our projections means understanding that not everyone will be like our parents (though our first impulse will be to think many people are) and not every threat will end in the catastrophe we may once have undergone.

Achieving mental well-being means understanding ourselves well enough to appreciate how much, thanks to our histories, we characteristically misunderstand. In particular, it means appreciating how many phantoms or dangers we have conjured up when reality is, in truth, more benign. It means unpicking the influence of the past to give due weight to the often more manageable facts of the present.

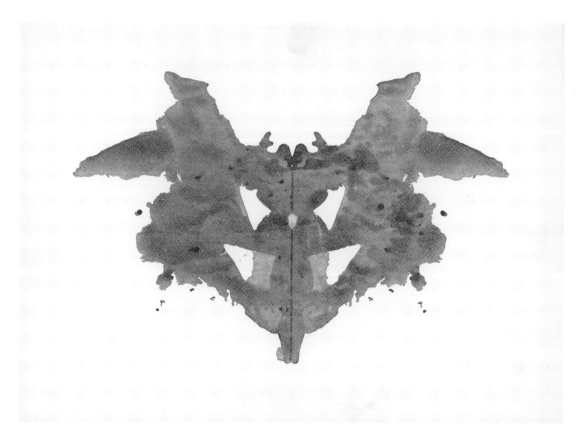

Hermann Rorschach, first card in the Rorschach
projective personality test, 1921

ONE OF THE MOST PAINFUL PATTERNS of mental life goes by the term obsessive compulsive disorder (OCD). To the sufferer of OCD, there is something that requires constant rumination and investigation: a poisonous gas is seeping into the house; a sharp knife may have been left out in the kitchen and could be seized on by an intruder; there's something inappropriate they might have looked at online a while back and the police might be on their way; their skin may be ageing prematurely and they need to look in the mirror constantly to learn more.

There is no use, in such cases, offering simple reassurance. No matter how often one explains that no gas is flowing, that the knives are locked away, that they haven't done anything bad online and that they aren't disintegrating physically, it doesn't work.

This is because the true object of terror lies somewhere else. OCD is often caused by a trauma from the past that has been projected into the future and metastasised into a paranoia. It can therefore only be treated by persistent detective work. We might, through patient investigation, discover that the terror of gas poisoning had its origins in a depressed mother who appeared to want to asphyxiate us in childhood; the dread of a sharp knife might reflect an unacknowledged fury at a caregiver who let us down appallingly. A fear of arrest might be connected to a sense of never being legitimate in one's family of birth. Dread of ageing might be a consequence of a parent's rivalrous jealousy. Fear has jumped its cause in random ways; one has been left with its shell, while its innards remain protected.

Our minds are likely to insist that their terror has nothing at all to do with the past – and simply everything to do with the gas tap or the dimpled brow. We should stay sceptical before such protests – if only because, were we to solve one surface worry without drilling into its ultimate cause, we'd simply facilitate its movement elsewhere. We need to travel back to the source of dread and drain it properly. The world may begin to feel like a safe place again once the person can remember their original injury, localise it and separate it off from modern-day anxieties.

As must seem entirely unbelievable to anyone experiencing OCD, a day might come when one has relearnt what dreadful event shook one's foundations and bred ensuing obsessions – and the present can start to feel as calm and as bearable as it should always have been.

Alena Kakhanovich, *The Long Time*,
from the 'Sleeping Garden' series,
Minsk, Belarus, 2018

ONE OF THE GREAT IMPEDIMENTS to understanding bits of our lives properly is our overly ready assumption that we already do so. It's easy to carry around with us, and exchange with others, surface intellectual descriptions of key painful events that leave the marrow of our emotions behind. We may say that we remember, for example, that we 'didn't get on too well' with our father, that our mother was 'slightly neglectful' or that going to boarding school was 'a bit sad'.

It could – on this basis – sound as if we surely have a solid enough grip on events. But these compressed stories are precisely the sort of ready-made, affectless accounts that stand in the way of connecting properly and viscerally with what happened to us and therefore of knowing ourselves adequately; if we can put it in a paradoxical form, our memories are what allow us to forget. Our day-to-day accounts may bear as much resemblance to the vivid truth of our lives as a postcard from Naxos does to a month-long journey around the Aegean.

If this matters, it's because only on the basis of proper immersion in past fears, sadnesses, rages and losses can we ever recover from certain disorders that develop when difficult events have grown immobilised within us. To be liberated from the past, we need to mourn it, and for this to occur, we need to get in touch with what it actually felt like. We need to sense, in a way we may not have done for decades, the pain of our sister being preferred to us or of the devastation of being maltreated in the study on a Saturday morning.

The difference between felt and lifeless memories could be compared to the difference between a mediocre and a great painting of spring. Both will show us an identifiable place and time of year, but only the great painter will properly seize, from among millions of possible elements, the few that really render the moment charming, interesting, sad or tender. In one case, we know about spring; in the other, we finally feel it.

This may seem like a narrow aesthetic consideration, but it goes to the core of what we need to do to get over many psychological complaints. We cannot continue to fly high over the past in our jet plane while high-handedly refusing to re-experience the territory we are crossing. We need to land our craft, get out and walk, inch by painful inch, through the swampy reality of the past. We need to lie down, perhaps on a couch, maybe with music, close our eyes and endure things on foot. Only when we have returned afresh to our suffering and known it in our bones will it ever promise to leave us alone.

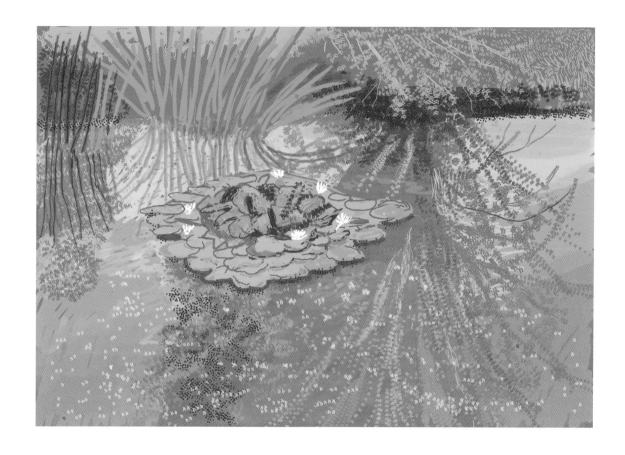

David Hockney, *21st May 2020*, 2020

FOR MOST OF HISTORY, nearly all thinking people have been strongly against drugs. This hasn't on the whole been for legal or health-conscious reasons. The argument has been more fundamental: drugs switch off our higher faculties, they tamper with our powers of reason and logic. And therefore they deny us our humanity because, as René Descartes (1596–1650) was one of many to point out, to be properly human is to exercise our minds: I think, therefore I am.

But of late, a new, directly opposed idea has come to the fore: that there might be a way of using a very specific selection of drugs within a strictly monitored setting in order to do something that philosophy has been extremely committed to since its emergence: to help us get to know ourselves better. By taking – in the company of a carefully trained psychotherapist – a powerful dose of one of three drugs – psilocybin, ayahuasca or MDMA – the suggestion is that one will be able to lose one's normal mind for four to eight hours but, simultaneously, gain access to important, formerly locked-off parts of consciousness in which insights essential to our flourishing are stored. We won't be rolling around in nonsense; we'll be reconnecting with foundational disavowed ideas and resolving mental afflictions created by trauma-driven denial or forgetting.

One of the central ways in which these therapeutic drugs can help us to think is by reducing fear. When we get stuck in repetitive trains of thoughts, it isn't because we are stupid but, principally, because we are afraid. But on MDMA, for example, one is so suffused by a sense of well-being that ideas that were formerly too daunting to approach will open themselves up for examination. We might have the chance to think properly for the first time about our difficult relationship with our mother, the origins of our workplace ambitions or the nature of certain paranoid obsessions that have proved inaccessible to standard therapy. We aren't, like partygoers, escaping our minds; we're engaging – in a mood of rare concentration – with their most challenging aspects.

It is easy to feel apprehensive at the mention of any drugs whatsoever: those who have used them for the past few centuries have seldom been among the most reassuring. But the imminent legalisation of a handful of drugs for therapeutic purposes may open up the topic to a new class of people: those who best love ideas and self-knowledge, those who want to think more deeply and sanely about themselves.

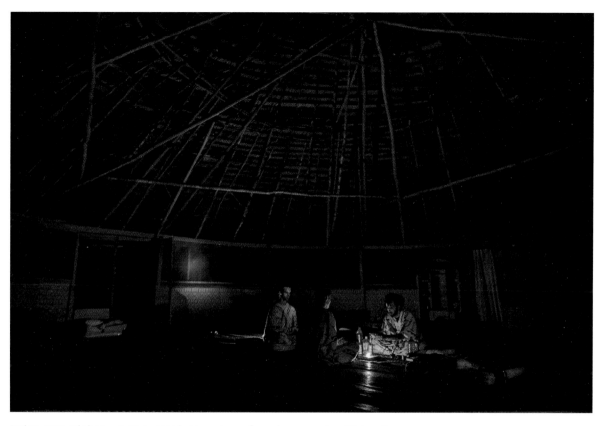

Brian Van Tighem, A man receives a cup of ayahuasca, traditional
Amazonian plant medicine used for visionary healing in a Shipibo
maloca in Peru

MOST OF US manoeuvre through the world under the casual assumption that if a thought is worth having, it will manifest itself to us. There is no need to wait for it carefully by the riverbank of consciousness; it will come when it needs to.

But another view, which owes much to the Eastern meditative tradition, proposes something different: we need to make an appointment with our own most important thoughts. Our minds are jumbled, chaotic places, constantly drifting towards distractions and evasions, and uninclined to wrestle with matters of substance or emotional import. They like to circle who said what to whom, what it would be nice to eat and what might go well with the new maroon top. Unless we are careful, we may lead our whole lives on the surface.

We therefore need to wall off time – it might be an hour before bed – in which we make an active effort to still our less productive currents of thought and concentrate on what actively counts towards our balanced and authentic progress through the years. We may start a meditation by asking ourselves head-on what we might presently be anxious about. We may not even have registered we were anxious – but once we remove distractions, we're sure to find a succession of worries ready to perturb us. We should unpack each one with kindly diligence, as a parent might the anxieties of a child at bedtime: what are we concerned about with the report? What should we do about lunch tomorrow? Is there a better way to arrange the upcoming holidays?

Next, we could consider the subtle or more obvious ways in which the world might recently have hurt us. We tend to be too brave for our own good, yet every day brings with it a new range of slights that sap our spirits when they are left unprocessed. We should reframe the insults we've received, explain to ourselves why someone might have acted cruelly and forgive those who cannot do better.

We might finish a meditation by anticipating the future: where should we be trying to steer to? What remains exciting, bold and invigorating? What pulses of interest have we faintly registered during the day? We should push our thinking further: what might we write next? What sort of job might we be doing this time next year?

After such investigations, our minds will feel like less frightening and burdened places. We will have put new flags in the territory. We will, in a process invisible except for the occasional tremor in our tightly closed eyes, have returned to ourselves.

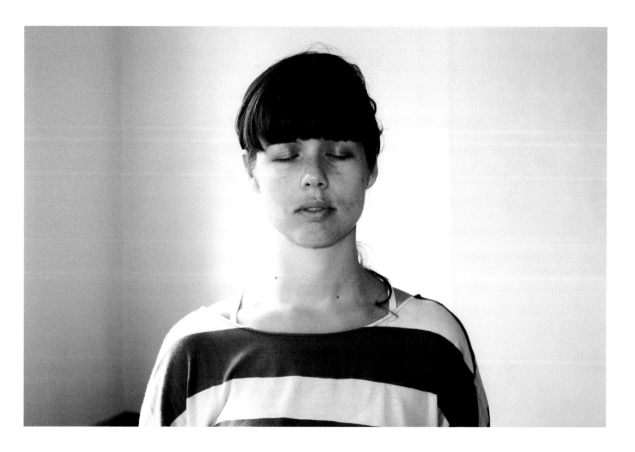

Guy Wilkinson, *Suryadarshini*, from the 'Meditation' series, 2017

THE IDEA THAT WE MIGHT—as the expression has it – 'lose touch with our feelings' is, when we reflect on it, a highly paradoxical one. How could we lose touch with feelings that belong to us? Where might they go? And what might be driving their loss?

We're built in such a way that an understanding of much of what our minds and bodies go through is in no way automatic; it is mediated via the acceptance and understanding of other people. We know well enough about some things: if, for example, we hadn't drunk anything for three days, we would know the truth soon enough. But many of our sensations are like bells that have no solid wire back to consciousness; they ring at a peculiar frequency that isn't picked up by our minds when these have been attuned incorrectly.

This may, for example, happen around tiredness. Our body may have grown extremely weary over many years, but consciousness might simply not be interested, because it's been calibrated to respond only to an agenda that sets store by the fast-paced pursuit of status and money. Or we might feel hugely anxious or in a rage with someone, but consciousness might not care because we have been ordered to be confident or extremely 'good'. Or there might be a profound sadness inside us, but the feeling might not earn our attention because we're meant to be privileged people with nothing to complain about.

Why do we overlook our feelings like this? Because we generally only notice those feelings to which other people, especially people in our childhoods, pay attention – and conversely ignore those that they sideline or belittle. If no one especially cares that we are worried, if the grounds for our anger would be refused immediately, if there's a dominant assumption that tiredness is for wimps, then we'll follow suit and disdain bits of ourselves as much as others have done. Knowing how to care for ourselves depends on having been cared for by others; we listen to ourselves because people around us have listened to us.

Reconnecting with our lost feelings therefore relies on a new, expanded sense of what it might be legitimate to experience. We have to be given permission to give our attention to as much of the sorrow, anxiety, anger or tiredness as may really be locked inside us. Put another way, we have to be loved properly, and so be allowed to register whatever we are actually going through without being belittled, stonewalled or humiliated. Love will allow us to enjoy what should always have been our basic privilege: to know what we feel.

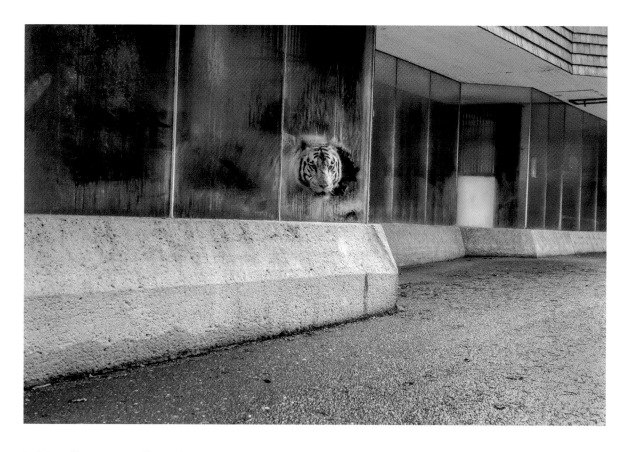

Radek Kalhous, *ZOO Liberec/3.12.2015*, from the
'Wilderness' series, 2015

THERE ARE FEW more important tasks for parents than to be able to listen properly to their children – that is, pick up on and give room to their children's moods, hatreds and enthusiasms, even when these run contrary to their own inclinations. It's on the basis of having been listened to with close sympathy and imagination that a child will later on be able to accept themselves, remain in touch with what they feel and find partners who are interested in their core selves.

Why should listening properly prove so hard for many parents? Partly because what children say and do can prove so threatening to parents' sense of their identity. We may as parents have said a very firm goodbye to vulnerability, imagination, frankness, sexual fluidity or sadness. But our children come into the world unaware of any such repudiations; what we have put into our shadow sides may lie in the midday sun of our offspring's young lives. The kids have no compunction saying that granny is a big fat poo or that they long to live in a bigger house. They may in addition be terrible at maths and hopeless at tying their own shoelaces. This may rattle us to the core: how could we have worked so hard to expunge weakness from our personality, only for it to show up in the next generation? How can they be so shockingly needy and difficult, so illogical and impolite?

There can be jealousy behind much of the resulting nonlistening. Parents may not take their children's cries to heart because no one paid particular attention to their own lamentations. Why would they be patient with another's petty sorrows when they had to grow up with brutal speed? The best way for parents to protect themselves against registering their latent frustrations and regrets can be to ensure that their children also don't get what they want.

Nonlistening parents are to be found constantly rewriting their children's experiences: 'That's nonsense,' they will say, 'I know you love going for walks in the rain!' Or: 'Why would my brave little soldier cry about something like that?' Or they'll insinuate that there is simply no way to devote oneself to something (ballet or business, being shy or dressing as a fairy) and remain legitimate and loveable.

The legacy of not being listened to is a split personality, in which we are unable to allow in the sadness or anger, vulnerability or confidence that our parents once denied in us. Properly growing up may involve asking ourselves a very unfamiliar question – what sides of me could my parents not accept? – and making friends with the answers.

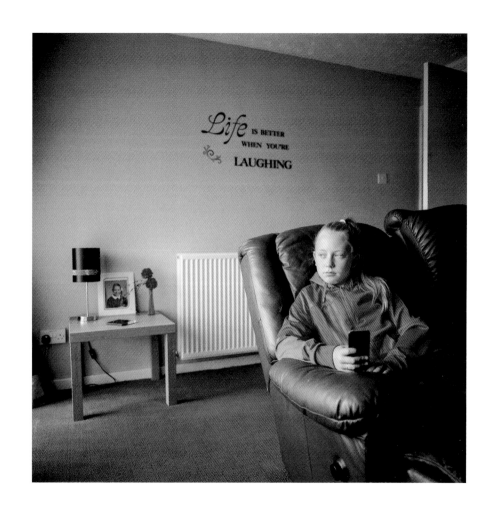

Margaret Mitchell, *Leah in Her Living Room*, from the 'In This Place' series, 2016–2017

IT'S AN ENORMOUS PRIVILEGE to have an adolescence – and, to an extent rarely spoken about, not everyone gets the chance to have one. Adolescence isn't just a particular time in one's second decade, and it won't unfold automatically simply when one reaches 14 or 17-and-three-quarters.

Adolescence properly understood is a state in which we're able to explore – with courage and newfound independence – who we might be outside of the projections and mental dictates placed upon us with enormous ingenuity and great force by our parents.

Parents are the greatest propagandists that any of us will ever meet – and part of their genius is that we rarely know what they are up to. Below the surface they are engaged in a ruthless and ongoing attempt to sell us a version of reality: to tell us what we are 'really' like, what life is truly about – and who they have been and what their motives are. It goes without saying that some of their ideas will be eminently correct, but the function of adolescence is to take a good long look at, and deal with, the ones that aren't.

Adolescence is an initially inarticulate and then gradually more discerning protest against everything that has come to feel false, ill-fitting and superfluously applied to our identities since we were born. We may realise, as we progress through adolescence, that we really aren't interested in particular sides of the workplace that our parents have held in high esteem, that we don't care about a given approach to morality or vision of politeness and goodness.

Good parents are secure enough not to mind; they can accept that their child has turned into a separate person. They can even take it if their children are furious for a while and see all their incompetence and stupidity without a filter of sentimentality or fear: what clever people they are to be able to perceive things so distinctly! What a tribute to one's parenting to allow such loathing to play out!

The difficulty lies with the parents who brook no such opposition, who are too vengeful, depressed or anxious to tolerate dissent and who force us to disown bits of ourselves in order to retain their love.

The good news is that it's never too late for an adolescence. We can start to have one as soon as we realise our right to define ourselves away from parental laws. We can even do it in secret. No one will have to know the critical task that is at play beneath our sober, middle-aged facades: a belated search for our true selves.

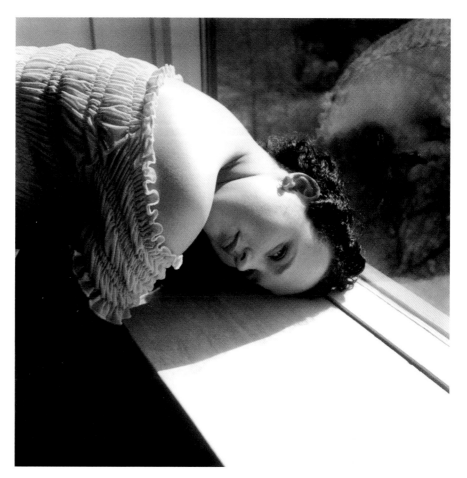

Hellen Van Meene, *Untitled nr.063*, 1999

THE WORD 'TRAUMA' – meaning a terrible event we live through that cannot be remembered but that generates painful symptoms – captures an acute paradox in our relationship to our own histories: some of what is significant in our lives is inaccessible to day-to-day memory; the more important something is, the less we may be able to recall it.

There seems to be a threshold of pain over which our minds won't go in order to retrieve an event. We'll recall with ease the pleasant childhood morning thirty years ago by the river when we fed the ducks. But we'll be sincerely unable to remember a moment that same day when our father abruptly lost his temper over an apparent triviality and, from nowhere, slapped us across the cheek and left us. The memory-retrieving part of our minds is like an eye that clenches shut in the presence of a flash and closes down when asked to archive and then recover incidents of intense fury, terror, ridicule or shame. The difficulties may be very large – a bomb, a physical violation – or apparently more modest – mockery, a prolonged absence. Yet what defines a trauma is not so much an objective score on a scale of awfulness as a subjective impression that an incident is too difficult for us to make sense of and poses too great a risk to our hopes of ourselves and those we want to love.

Though we may be nominally protected by our ignorance of our traumas, the overall impact of our disconnection has the power to derail our lives. We may not have kept in mind that our father was a deeply frightening man, but it's on this basis that we have begun to fear all men. We may not remember our mother's terrifying competitiveness, but its submerged presence is what has bred in us a habit of removing ourselves from any position in which we may triumph. Problems don't go away because they have been sent to a catacomb: they have a greater impact precisely because they can't be brought to consciousness and resolved through conversation and sympathetic analysis.

The challenge of recovering from trauma is that we can't on command remember what we do not know we have forgotten. We need to proceed indirectly, awakening ourselves to the possibility of buried difficulties on the basis of a range of otherwise inexplicable present-day fears. When there is no obvious reason for our body dysmorphia or insomnia, paranoia or despair, we should start to dig – in the presence of those who love us and understand our minds – to prevent our stories from being controlled by figures of our past.

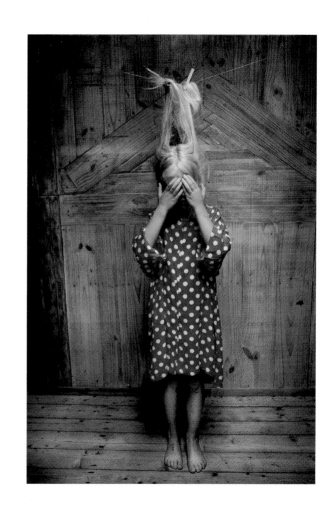

Vanja Bucan, *Untitled*, from the 'Anatomy
of False Memories' series, 2015

WE ARE USED TO THINKING of what we call the news as a tool that can help us to vanquish ignorance: we will, thanks to its updates, properly understand what is going on and where importance lies. But if we examine the role of this phenomenon with greater scepticism, we may find that it is as responsible for blinding us to ourselves as for introducing us to the complexities of so-called reality.

The presence of the news continuously – albeit slyly – encourages us to forget entirely what we actually feel in relation to certain events. The way stories are told invariably promotes one particular set of responses: *this is outrageous, he is bad, this is tragic, she is a victim, they are repulsive ...* These verdicts may seem entirely fair, but only too often, to an extent we are bullied into forgetting, they don't quite. We might in our hearts – oddly but authentically – not think that something is such a tragedy after all; we might not really care in the least about something that we have been repeatedly pressed to think is vital. And we might fancy someone we're definitely meant to hate. The news quietly closes off alternative avenues of investigation and response.

At its core, the news is opposed to introspection. It doesn't want us to know ourselves better and compulsively disconnects our emotions from their true targets. It takes our nascent feelings of anger, for example, and redirects them away from our acquaintances or early caregivers to causes that aren't remotely for us to bother with. It co-opts our fears to an ever-changing roster of monsters, and blinds us to what we really need to be vigilant about before it's too late.

Because of the prestige that we have collectively accorded to the news, the hurried judgements of skittish, third-rate minds are allowed to determine our view of 'normality'. It is universally taken to be sensible to 'catch up on the news', rather than, as is actually the case, for the most part dangerous and irrelevant. There is almost nothing we really need to know outside of what has happened in our own heads and in the lives of ten or so people who count on us.

We would surely be made to feel untenably odd if we decided – as really we should – that we were from now on going to check the news only once a week, and the rest of the time devote ourselves to exploring the contents of our soul via meditative reflection.

While pretending to inform us about the state of the world, the news has become a formidable instrument of self-forgetting.

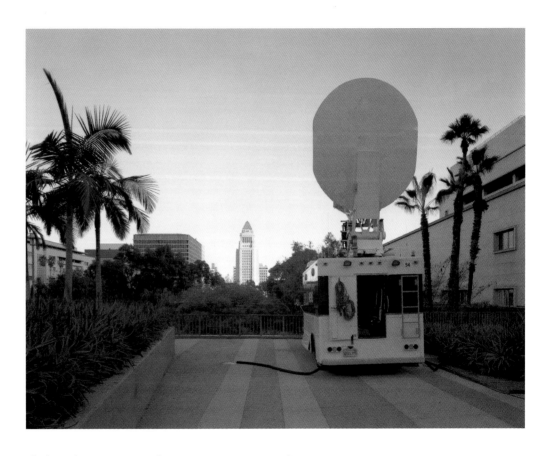

Christopher Dawson, *Britney Spears, Los Angeles,*
California, from the 'Coverage' series, 2008

ONE OF THE MOST USEFUL realisations we might come to about ourselves is that we are 'paranoid'. The word is easy to laugh off as impossibly eccentric, evoking people who insist that they are being tailed by the secret service or watched over by an alien species. But the reality is a lot more normal-looking and far less comedic-feeling. To be paranoid in the true sense is to suffer from a repeated feeling that most people hate us, that most situations are extremely dangerous and that some kind of catastrophe is likely to befall us soon.

It may not be immediately obvious what connects up, for example, our impression that a colleague is taking us for a fool, with our fear of being talked about unkindly by our friends, with our impression that the waiter has deliberately placed us at the worst table and our dread that we're about to be caught up in a scandal.

But our sense that the world is permanently and imminently conspiring to belittle, attack and humiliate us is most likely the outcome of a particular string of experiences of belittlement, attack and humiliation that occurred at the hands of people in our formative years – and yet that has been carefully submerged. And this will have been done because we have implicitly preferred to fear the world rather than acknowledge the reality of the torment we underwent at the hands of characters – who might also be our mother or father – whom we would have liked so much to trust and to love.

It's unfortunate that our minds need to discharge their toxins somewhere, and that if they have been blocked from doing so in the appropriate location, they will seek to do so anywhere that feels remotely relevant: the office or the restaurant, the party or the newspaper article. The hatred and viciousness we fear from colleagues, friends or social media is only a proxy for what we once received from sources close to home – and that we have lacked the support required to return to their senders.

Understanding who has crushed and scarred us constitutes a critical part of adult self-knowledge. It is also an insight we may be deeply reluctant to secure, opting to be forever terrified rather than to raise arguments against our treatment by caregivers whom we have chosen to believe are innocent. It may one day feel as though far fewer people are actually laughing at us and that there is far less risk of a scandal soon – once we understand that the mockery and shaming we anticipate for tomorrow already unfolded in our heartrendingly anguished and unexplored yesterdays.

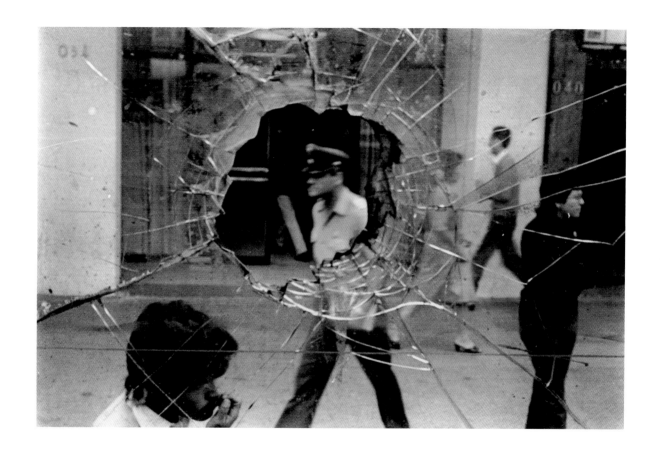

Álvaro Hoppe, *Calle Alameda, Santiago de Chile*, 1983

WE'RE UNLUCKY ENOUGH if we meet people who want to do us wrong and show us contempt. But this is as nothing next to the monumental bad luck of encountering people who do this to us while also being skilled at pretending that they aren't; those master manipulators who are at once innocent-seeming and, deep down, profoundly scheming. These people won't only hurt us; they will do something far worse: rob us of our understanding of ourselves and strip us of basic trust.

However good we might be at fighting overt antagonists, many of us are unprepared to detect ones that have entered our intimate lives. Yet this doesn't mean that some very dark things can't unfold there. There are people who have been so badly hurt in their early lives that they are committed to exacting revenge on anyone who comes too close to them: they may semiconsciously be seeking to exercise on their partners a latent rage against a dead parent; they may want to punish a bullying sibling or release themselves from a sense of intolerable vulnerability created by early abuse.

Such dark possibilities are rarely spoken of in useful terms. There are plenty of popular references to 'psychos' but far fewer patient analyses of how minds can be distorted and how widespread longings for vengeance may be.

When we meet with difficulties, we have two explanations to fall back on: the first is to doubt ourselves. The second is to wonder whether the other person might be ill. If we almost always pick the former, it's because of how familiar and reassuring it is not to take our own side. It is much easier for us to think that we are (as they also tell us) irrationally prone to anger, over-excited, 'insane' and complaining for no reason – rather than deep in a relationship with a cruel soul.

Those who are most prone to being gaslit in love are those who may have been gaslit by their own parents. The idea sounds yet more curious, but parents too can be adept at polishing their reputations and will insist that they are kind while simultaneously expending hostility on their confused child.

Despite decades of training in self-doubt, we may need to do a remarkable thing: trust in what our unhappiness is telling us about those we think of as good. The test isn't whether they tell us they love us; it's how at peace they make us feel. We may need to think a bit less badly of ourselves and substantially worse of some sweet-seeming characters who claim with great sincerity to love us – and don't.

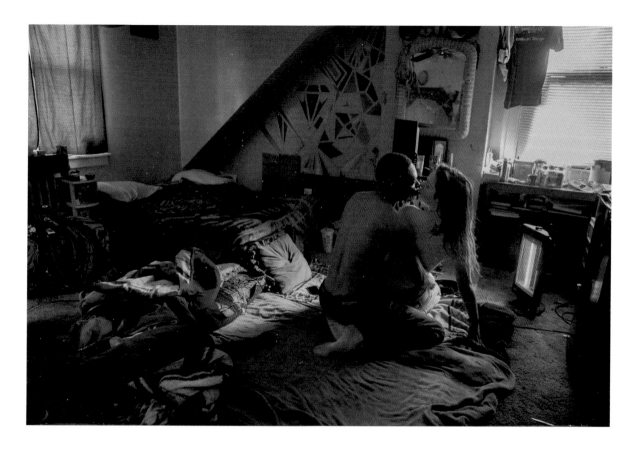

Barbara Peacock, *Claire & Tee*, '*We Are Colorblind*',
Detroit, 2023

WE COLLECTIVELY SPEND a lot of time looking for ingredients that help us thrive in business – among these, confidence, teamwork, marketing and a knack at numbers. But one thing that rarely comes up is self-knowledge.

This is to miss just how many businesses devote their energies to making products and services for customers that don't exist. These organisations apply their best minds to attempting to solve problems that aren't connected to anything that might conceivably bother human beings as they currently exist. These businesses might be publishing books that have nothing compelling to say, opening restaurants with oddly off-putting menus or (in extremis) designing parody airborne umbrellas that no one would want to pilot in a rain shower.

And they do so for what may in essence be a single hugely consequential but simple reason: they haven't asked themselves what they might truly need more of in their lives. Modesty has held them back. They haven't had the courage to imagine that what secretly interests them might be of sizeable interest to others – and, conversely, that what bores them may be an indication of an important fault, whatever colleagues or research agencies might indicate. They have been too shy to push forward their sincere thoughts about what it would be pleasant to eat for dinner or what device they would need to solve crucial domestic challenges. They have failed to consult their most accurate bellwether of desire: themselves.

Good innovators, on the other hand, are those rare beings who are adept at noticing faint yet vital signs of interest from within their own minds, even when these signs are ignored by the market as it stands. They dare to think: *I might love a hotel where … Wouldn't it be nice if there was a machine that … Imagine if when it came to banking …* They have not surrendered their hold on their own pleasures and are therefore optimally positioned to intuit the desires of others.

What we call profit is in essence the reward for looking more deeply into our collective semiconscious needs than the competition – and thereby of knowing the audience better than they know themselves. In the best new businesses, we recognise our own latent desires, returned to us with discipline and coherence.

This is why one of the unexpected priorities of an education in business might be to instil a greater trust in our own appetites. The future of successful enterprise may lie in sticking more loyally to some of our most personal excitements and needs.

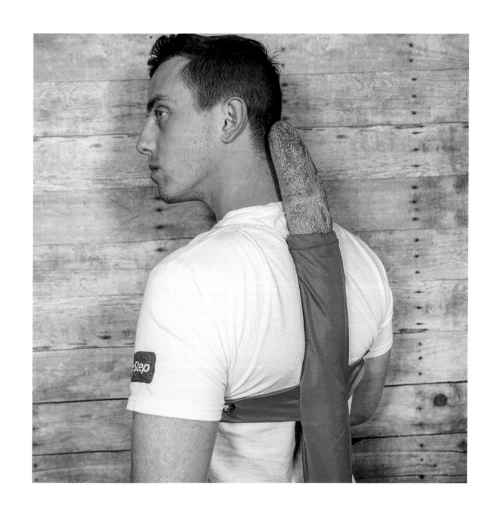

Matty Benedetto, *The Baguette Pack™*, from 'Unnecessary Inventions', 2019

WHEN WE TRY TO IMAGINE a good place for thinking, we often picture a library: rows upon rows of the most penetrating and informative books, ready to enhance our intelligence and guide our thoughts.

The image is a symptom of a prevailing understanding of the mind: that what we principally need in order to grow cleverer in ourselves is the thoughts of other people.

But the challenge is arguably a little different. Every mind already has an extraordinary number of ideas, sense impressions and perspectives packed within it. The problem is not that the mind is empty but that it has been left unexplored. We have not begun to make use of the riches inside us. Thoughts lie around in tangles, room after room is packed with volumes that no one has read. We don't need to pour yet more into our minds; we need to sift and make sense of the archives that are already in place.

The reason why we haven't as yet explored our minds is moving and sympathy-inducing: we are scared. We are afraid that our buried sensitivity, insight and emotion will, once it is resurrected, let loose an impossible degree of pain.

The café seems to know this and to want to help us out. A crucial benefit of such a place is that we're not –

ostensibly – supposed to be doing any intellectual work there. We're meant to be relaxing, taking in the view and ordering an espresso. We are bathed in distractions, both auditory and culinary; people are chatting, parents are arriving, machines are hissing. And yet it is exactly this surface activity that gives the skittish part of our minds enough to be getting on with in order to leave the other, more curious branch of consciousness free to explore. One side of us can be studying the new waiter's outfit or working through the apricot tart, while another is daring to consider whether our relationship is really sound, or what constitutes a meaningful life. No sooner have we hit on a difficult moment in our reflections than we can – as it's hard to do in the library – jump out of our train of thought and have another bite of cake.

The café may look like a location in which to unwind, but this masks its function as a locale that can for a time fool the nervous part of our minds into doing what we have been scared to do: think. Anyone can equip their intelligence with concepts drawn only from other people. As the café appreciates, the really hard work is to examine and understand ourselves.

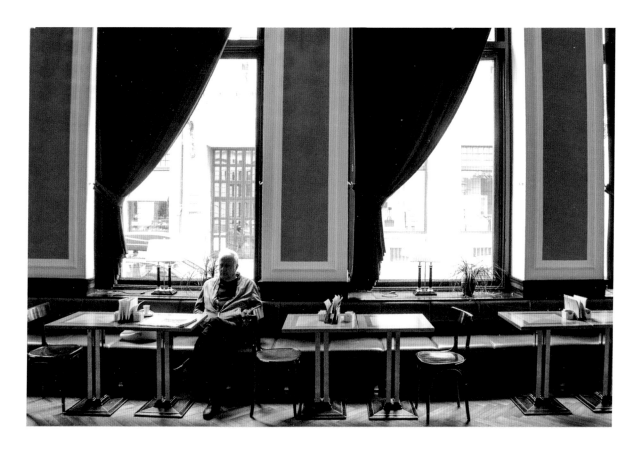

Nik Erik Neubauer, *Kavarna Union Cafe, Ljubljana*,
25th April 2015

IN AN IDEAL WORLD, what should define someone as a writer isn't that they publish books or give talks at literary festivals; it's that they belong to a distinct group of people who – when they are in distress – gain relief from jotting things down. 'Writers' in the true sense are those who scribble – as opposed to drink or chat – their way out of pain.

The act of writing in a journal is filled with therapeutic benefits. So deeply do certain ideas threaten the status quo, even if they ultimately offer us benefits, that the mind will ruthlessly 'forget' them in the name of a quiet life. But our journals are a forum in which we can galvanise ourselves into answering the large questions in our lives: what do I really want? Should I leave? What do I feel for them?

We may not quite know what we want to say until we've started to write. The first sentence makes the second one clearer. After a short paragraph we start to know where this might be going. We learn what we think in the process of being forced to utter ideas outside of our swampy minds. The page becomes a guardian of our authentic, elusive self.

Here we can make vows and attempt to stick to them. Ordinary life can seem to have no place for stocktaking and moments of grand enquiry. But the page demands and rewards them: what am I trying to do? Who am I? What is meaningful for me?

We can look back at what we've written and understand. The page is a supreme arena for processing. We can drain pain of its rawness. We can get used to disasters and stabilise joys. We can turn panic into lists. We won't need to be so jittery in the world outside after we have told the notebook all this.

The page becomes a laboratory in which to try out what might shock and surprise. Leave the job. Tell them it's over. We don't need to honour everything we say. We're giving it a go and seeing how we feel.

Looking at what we have written should be embarrassing, if what we mean by that is hyperbolic, disjointed and wild. If we aren't appalled by much of what we have written, we aren't being truthful – and therefore won't learn.

If in ordinary life we make a little more sense than we might, if we are a bit calmer than we were, it's perhaps because – somewhere in a drawer – there are pages of tightly compressed handwriting that have helped us to understand our pain, safely explore our fantasies and guide us to a more bearable future.

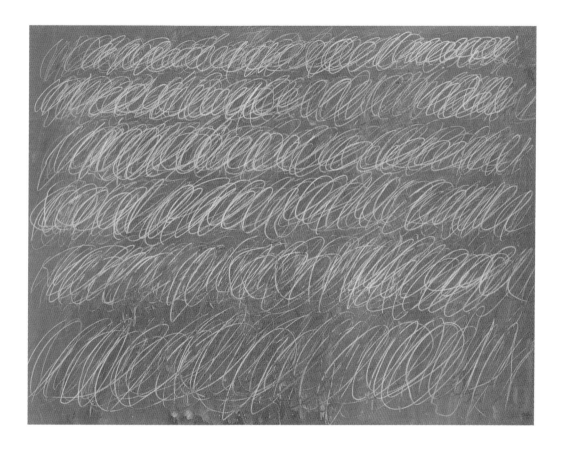

Cy Twombly, *Untitled*, 1968

ONE OF THE MORE CURIOUS aspects of the way we are built is that it can take us a very long time indeed to work out what we need in order to be happy.

We might assume that the process is obvious; what could be more straightforward than to want? We've ostensibly been doing it since we were 4 years old and began a powerful campaign for an electric train. The issue is not that we have no appetites, but that it can take such a long time for these to become either accurate or authentic.

We start by wanting primarily according to what others around us want. Which may mean that – at varied ages – we acquire a bomber jacket, a barbecue, a marriage, a career in finance, a juicer, a divorce and weekly Pilates lessons.

We may be in our fourth decade before we acknowledge just how unexpected and distinct our characters and requirements are – and nurture the courage to do something about it.

We might grow honest enough to realise that we would be happy never again to see most of the fakes we'd been thinking of as 'friends' for years. And, conversely, we might determine that we now want to hang out exclusively with people who've had nervous breakdowns, spent time in prison, know how to cry and actively don't give a damn what the world thinks.

We might at the same time realise that we abhor what news and social media do to our minds and delete everything, until our phones can barely tell the time any more. We can be proud of all the nonsense that we no longer have to know about or be scared of. The world will go its own merry way and we won't have to follow every part of the bile-filled story at minute intervals.

We may also stop trying to impress people we hate. Our mother cared intensely about social status and being famous – and, under her aegis we gave up a great many years of our life. Good for her and a pity for us, but we're done with that now, and three weird friends, a big dose of misanthropy and a hut in the woods are beckoning.

We are going to be dead pretty soon and all the cancer stories point us in one direction only: towards the need to stop being a craven, imitative, secondhand, timid flunkey and herd animal. We need to throw out all the socially prescribed junk and honour the contours of our own unique characters before it's too late. After a lifetime of imitation, fear and surrender, we may finally have to grow a backbone – and become loyal to who we actually are.

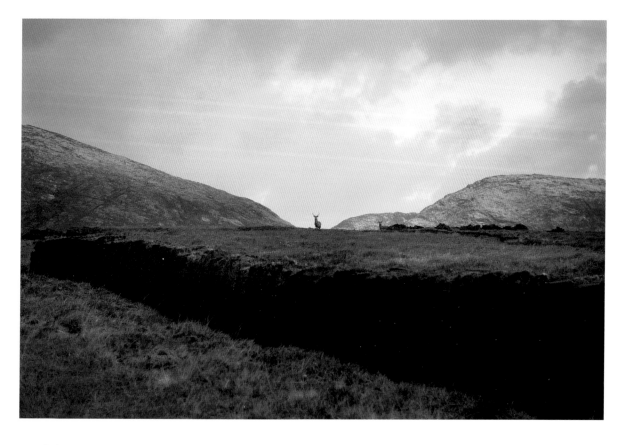

Laetitia Vancon, *Landscape on Lewis Island, Uig*, from the
'At the End of the Day – *Aig deireadh an latha*' series, 2016

EVERYDAY, IN SMALL and large ways, we're encouraged to pretend to be something we're not. Afraid of being hated and shunned if we were to say what we really wanted and thought, we give in to the pressures emanating from the mob – who might be anything from our families, to our colleagues, to an actual mob in the street or on our phones.

The process of inauthenticity starts at the most bathetic levels. We want to go to bed; they want one last drink. We've got work tomorrow, but they keep saying 'Come on!' very loudly and with good cheer and so we trot along meekly, sit in a crowded bar for two more hours, wake up groggy and exhausted the next day – and hate ourselves for floating helplessly on the currents of the wishes of others.

At mealtimes, we laugh at jokes we don't find funny and pretend to see films we haven't seen. And, of course, we keep saying yes to social events that we don't want to attend. We promise ourselves that we're going to move to a city we don't hate – and then stay in place for another decade.

It's the work of a lifetime to learn to protect our own interests against the push of coercive forces. What a major achievement when we can finally feel brave enough to tell friends that we would actually really like to go to bed now or decline a business offer that would destroy our next year. Or simply stop smiling automatically at any remark, however idiotic, uttered by anyone we ever come across.

It takes so long to defend our interests like this because of how little, deep down, we approve of ourselves. *What does it matter what we think*, we implicitly think, *when someone else believes they are so funny?* Why not ruin another evening of ours if a so-called friend is convinced that they need us at their table? No one ever particularly taught us how to love who we are – and we're following suit.

It's also fear that keeps us in place. Somewhere in our past, there's likely to have been a furious, unreasonable person who terrified us – and we don't really want to encounter anything like that ever again, which is why we put in a lot of effort to skirt and appease the risk of upsets and tantrums.

The solution is not to catastrophise the consequences of disappointing others. They'll survive that we can't make dinner; they'll forgive us for quitting a social occasion early. The fears are in our heads, not in the world. We can be loved and refuse others' plans. We can stop smiling until someone or something genuinely amuses us.

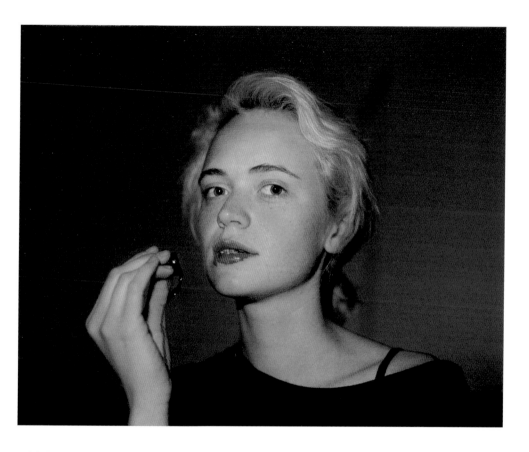

Tabitha Barnard, *Clot*, from the 'Cult of Womanhood'
series, 2018

PART OF THE PAIN of growing older is that we can start to see how much, at certain points, we misunderstood ourselves, what the costs of missing self-knowledge were and how beautiful it could be if we could just build ourselves a time machine and go back and correct all our mistakes.

It's because, at the age of 7, we had no idea about standing up to an adult, so we let ourselves get trampled upon by a parent and then grew up as a target for bullies.

It's because, at 17, we were so uncertain about our value that there was no way we could seduce someone we liked and so we wasted what might have been some of our most promising years in loneliness and self-hatred.

It's because, at 30, we couldn't understand how our romantic tastes had been formed by our family histories, so we embarked on an incautious relationship that spoilt multiple lives.

The better responses, when we do achieve them, are so simple as to be almost insulting. But something can be no less crucial for sounding 'minor': a missing screw can, after all, bring down an airliner. We may realise – far too late – that we need to believe in ourselves, live by our own values and be free.

If only we could go back to our younger selves and whisper to them such advice: we'd have left home with our dignity intact, we'd have had the love we craved, we'd have spared ourselves relationship agonies. It's so tantalising; no wonder we often stay up late fantasising about being able to go back, knowing then what we know now.

But not picking up key lessons wasn't a casual oversight. Wise lessons were around, but we weren't ready. Our inattention was inevitable rather than accidental. We might have laughed defensively if someone had suggested going to psychotherapy aged 17. We would have called emotional intelligence 'psychobabble'. We were wedded to our illnesses.

We might try to be kinder to ourselves by recalibrating how easy certain emotional steps are. They can certainly be summed up to sound simple. But there is nothing simple about correcting mental unwellness. It can be the work of a lifetime, and the achievement of which we are the most proud: to one day be able to feel content with ourselves, not scared all the time, reconciled to our careers and holding the hand of a person who loves us. That only ever looks easy; in reality, there's nothing more complicated in the universe.

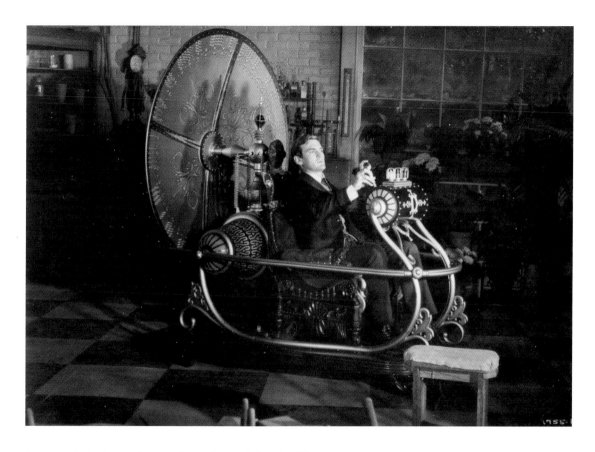

Actor Rod Taylor tries to fast forward in the film
of H.G. Wells' novel, *The Time Machine, 1960*

SOME OF THE REASONS why we find it so hard to understand ourselves – and end up doing and buying so much that doesn't seem to make us happy – has to do with living under a system that uses extremely intelligent means constantly to confuse us about what it is we actually need to be content.

For example, we may have felt slightly unhappy all morning about the state of our relationship and the direction of our lives. If we had been properly advised, we might have sat with a sympathetic therapist for a few hours and analysed our inability to stand up for our interests and our shyness when trying to connect with new friends. But a ten-trillion-dollar fashion industry got in the way. It whispered to us that our unhappiness had other causes; that it was down to the absence of a crocodile-skin handbag and a pair of reflective ovaloid sunglasses. And so, we spent the afternoon on Sloane Street and returned to our hotel feeling exhausted, confused and – for reasons we can't exactly grasp – distinctly tearful too.

It's a phenomenon that keeps being repeated across areas of consumption: we exchange a sincere engagement with our woes for superficial forays in distracting, fun palaces. What we buy isn't what we need.

Capitalism as it is currently arranged doesn't remotely stick to our true needs. In order to generate profits, it constantly excites in us a range of false desires that have no sound role to play in a genuinely satisfied life. And it does so by cannily connecting its superfluous products with elements that it knows we really long for and could benefit from, like close relationships, peace of mind and warm connections with our children. This is why so many cars are promoted via billboards that speak of cheerful family moments. It's the love and the intergenerational closeness we crave and yet – because we're easily confused creatures – it's the overpriced vehicle we end up investing in.

Were we to cater to our genuine wants, we might invest heavily in relationship therapy, in guides on how to get close to our children, in lessons on how to manage our frustrations and seminars on making interesting friends. The biggest corporations in the world would be those that were best able to foster in us the classical trinity of virtues: goodness, truth and beauty.

We don't need to abolish capitalism; we need to align it with an accurate picture of self-knowledge, and of the true flourishing of our souls.

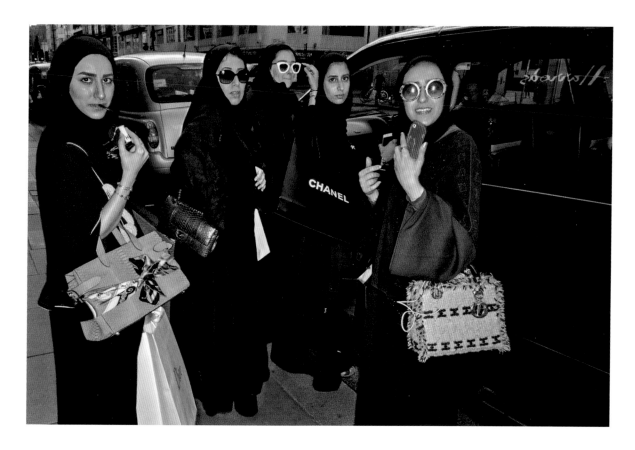

Dougie Wallace, *Untitled*, from the 'Harrodsburg'
series, 2018

THE WESTERN INTELLECTUAL TRADITION suggests that, in order to be happy, what we need to do most of all is go out and subdue the world: secure resources, found businesses, run governments, gain fame and conquer nations.

By contrast, the Eastern tradition has told us something very different. It has insisted that contentment requires us to learn to conquer not the world but the instrument through which we view this world, namely our minds.

It won't matter, says the East, how lustrous and perfect our achievements end up being – how much money we accumulate, how many friends we acquire, how feted our name is – so long as our minds remain open to being troubled at any point by our emotional faculties. A fortune is of no use at all so long as one is nagged by paranoia. An unhappy relationship destroys any advantages of an esteemed name.

Given this vulnerability of external goods to the vagaries of the mental realm, the Eastern tradition advises us to stop spending our time trying to rearrange the material building blocks of existence only then to fall foul of psychological ills – and to focus instead on learning how to control and manage the inherently unruly and hugely complicated instrument through which the external world reaches consciousness. Rather than striving to build empires, we need to spend years examining how we think and dream; we have to reflect on our families, the economic systems we were brought up under and the biological and cosmological order of nature of which we are an infinitesimal part. We have to learn how to breathe in such a way as to allow maximal oxygen to reach our frontal cortex and to hold our bodies so that our organs are not crushed and our blood flow subtly impeded. We need to be able to sleep a regular number of hours and remove all distractions and excitements that might disturb our streams of thought.

We should take the East's warnings seriously. However hard we strive, it is logical that we can only be as happy as our minds are at peace. And given how vulnerable we are to mental disturbances, and how short our lives are, we should on balance almost certainly spend a little more time on our psyches and a little less time on our plans for a second home and a New York office.

The West has produced too many unhappy playboys, and the East too many genuinely peaceful sages, for us not to shift our attention away from conquering the world towards taming our minds.

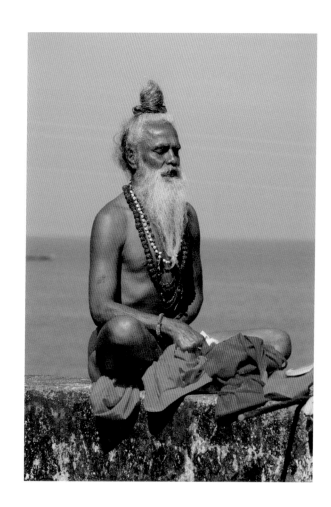

Kiran Anklekar, Hindu man meditating

ONE OF THE PARADOXES of trying to understand our minds is that, at particular moments, we need to acknowledge that what passes through them – the ideas we entertain and the moods we're in – may have very little to do with the workings of these minds themselves.

It may, for example, suddenly seem as though we have a new and very specific take on the world: we are sure that we should leave our job, say goodbye to our partner and never see our ungrateful children again. And yet, with hindsight, we may realise that these ideas were not necessarily logical or true, they were just emanations of a hard-to-notice detail: that we had missed out on four hours of sleep the night before or hadn't drunk anything since early morning.

Much that we think about – though it seems to be rationally founded – stems in essence from the ups and downs of the complicated bodily envelope we're entwined with. Our thoughts can predominantly be the result of what time we went to bed and how our blood-sugar level is doing.

This can sound hugely insulting. Surely we are wiser and cleverer than to be knocked off course by a sugary drink or a poor night? But we would be even wiser to follow, in this regard, the instincts of all good parents of young children.

When they see their toddler swiftly turning tetchy, they know that they are not witnessing an inexplicable character transformation in their formerly pleasant charges. They look at their watch, make their excuses and hurry upstairs to put the young one to bed for an hour. The mind will return to its usual state soon enough; it just cannot hope to do so while supported by a flagging body that's done three hours of energetic cartwheels or ball games with the neighbour's cocker spaniel.

We should understand ourselves in similar terms. When we are filled with tragic thoughts, we should remember that there are always dark perspectives we might adopt. When we do so, therefore, it isn't necessarily because our minds have uncovered new and solid reasons to despair; it's just that we lack the energy to bat away our fears. We say, 'I'm having bad thoughts *and* I'm exhausted'; we should learn to say, 'I'm having bad thoughts *because* I'm exhausted.'

To know ourselves never means knowing just our minds; it means tracking the decisive ways in which these minds are daily manipulated by our bodies and should, before we listen to them any further, be put down for a nap or sent on a long walk around the park.

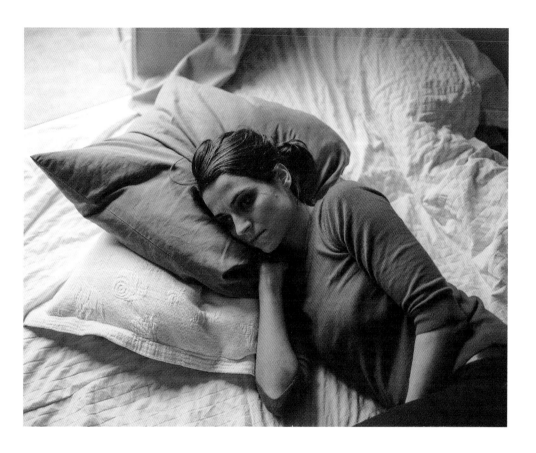

Alex Crétey Systermans, *Sidonie, Paris, 2012*,
from the 'Familiar' series, 2012

IT'S AN EMBARRASSING CONFESSION, but for a certain group of us, a great deal of our lives is spent asking the same question, week after week, always with the same blend of frustration, despair and puzzlement: why am I so lonely?

Why, in other words, do I so often find myself at odds in social groups; why can't I more easily connect with people; why do I not have more friends worthy of the name?

It's tempting to jump to the darkest conclusion: because I am awful; because there is something wrong with me; because I deserve to be hated.

But the real answer is likely to be far less punitive and, in its way, far more logical. We, the isolated members of the tribe, are lonely for a very firm and forgivable reason: because we are interested in introspection, and they – the others – for all their intelligence and wit and strength of mind, are not.

They may have many hobbies and passions and lots to say about a host of things, but they are simply not interested in looking deeply inside themselves. It is not their idea of fun to lie for a long time in a bath or a bed processing events in their interior lives. Introspection is not their thing. They haven't told us this in so many words – and they never will;

they don't even realise it perhaps. We simply have to surmise that this is the case on the basis of external evidence: that we never feel we have much to say to them, even though – objectively – there might be so much to share.

It's the lack of introspection that explains why conversation with them so often gets stuck in odd places discussing the price of train tickets or the best way to prepare muffins. It explains why, when we try to nudge the conversation onto something more intimate and vulnerable, we seem somehow never to manage and end up in yet more rounds of discussion about the sports results or the new political scandal.

We should accept that most of our acquaintances – however much they might in theory want to be friendly – do not want to do so at the cost of looking inside their own minds.

And we for our part are lonely because we are operating with a notion of intimacy that is far less common than we torture ourselves by imagining. We will be blessed if we meet just one or two people in a lifetime who want to play as we do. The rest of the time, we shouldn't compound our problems by feeling lonely that we're lonely.

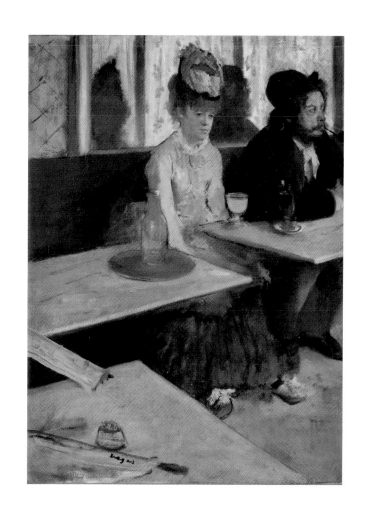

Edgar Degas, *Dans un café (Absinthe)*,
1875–1876

EVERY YEAR, NATURE quietly takes us through a moral lesson that has much to teach us about how we might relate to certain of the more dispiriting and despair-inducing moments in our own development. Beginning in mid-October in the northern hemisphere, the temperature drops, the nights draw in, the earth turns cold and hard, fog lies low over the land and rain drives hard across the austere, comatose, grey-brown landscape. There is nothing immediate we can hope for; now we have nothing to do but wait, with resigned patience, until something better shows up.

Far more than we can generally accept, our minds too have cycles. We cannot be permanently fruitful or creative, excited or open. There are necessary times of retrenchment when, whatever we might desire, there seems no alternative but to stop. We can no longer be productive; we lose direction and inspiration. We are immovably numb and sterile.

It can be easy to panic: why should such a paralysed and detached mood have descended on our formerly lively minds? Where have all our ideas and hopes gone? What has happened to our previous animation and gladness?

We should at such times take reassurance from the late November landscape. Certainly, things are lifeless, cold and in suspension. But this is not the end of the story; the earth is like this not as a destination but as a phase. The deadness is a prelude to new life; the fallow period is a guarantor of fecund days to come. All living organisms need to recharge themselves; old leaves have to give way, tired limbs must rest. The dance and ferment could not go on. It may look as if nothing at all is happening, as though this is a trance without purpose. Yet, deep underground, at this very moment, nutrients are being gathered, the groundwork for future ebullience and dynamism is being laid down, another summer is very slowly collecting its strength.

As nature seeks to tell us, we cannot permanently be in flower. We need moments of repose and confusion. There is nothing to fear. Things will re-emerge. We should make our peace with our own midwinters – and lean on nature's wise accommodation to strengthen us in our pursuit of serenity and patience.

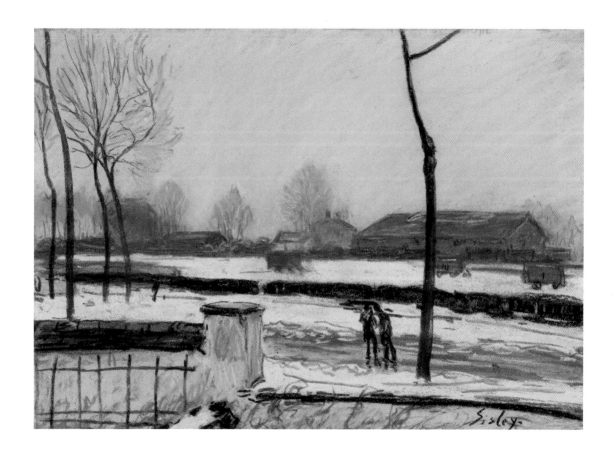

Alfred Sisley, *Winter Landscape, Moret*, c. 1888

HOWEVER HEALTHY IT OFTEN IS to try to fit in and assume we must be just like everyone else, there are also benefits in sometimes accepting that we might simply be rather odd – though this needn't particularly be a cause of concern or shame.

Perhaps we belong to the peculiar tribe of those who love to introspect – that is, to try to make sense of themselves and to understand the psychological mechanisms they inhabit. We, the happy odd few, belong to that minor clan of the avid self-knowers who take entirely to heart the Ancient Greek command to 'know yourself'.

To be so intensely concerned with self-knowledge has probably equipped us with a number of strange traits. We are likely to enjoy our own company very much. It's never a problem if someone cancels dinner on us. We might keep a diary where we spend hours taking matters apart. We might like solitary walks in the evening. We might read a lot but in a distinctive way: always looking out for the ways in which the words of others shed light on, and more clearly define, bits of ourselves. In museums, we're interested in how culture informs psychology. We're likely to be impatient with people who seek relentlessly to stay on the surface of things.

In love, half the fun won't be about sex or cuddles, it will be that there is someone there to discuss one of the world's most interesting phenomena – relationships – in real time with us.

We might try therapy and even though we may have had our share of disappointing shrinks, it will continue to be an area of intrinsic fascination: many of our favourite books will be psychological ones. As therapy inspires us to do, even though it might have been a long time since we lived with our family of birth, we will continue to explore how the past informs our present; we're never quite done with reflecting on Mum and Dad. We're no longer angry with them as we once were; we're just very interested.

People may often try to persuade us to do other things they call fun – go to the beach, come to a party, go shopping – and even though we'll agree and there'll be pleasant moments, the truth is that our favourite pastime remains sitting at home, probably in bed, with a notebook, trying to work out what it means to be alive.

That's ideally how – after many years – we'd like death to find us. Not scared or oblivious, but curious and attentive.

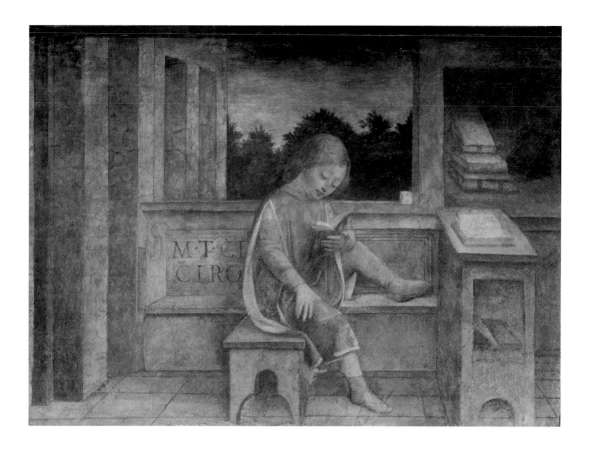

Vincenzo Foppa, *The Young Cicero Reading*, c. 1464

Illustration List

p.11 Apollo 11 pre-launch breakfast, Cape Canaveral, Florida, 16th July 1969. Photo NASA

p.13 Rémy Soubanère, *Untitled*, from the 'Alphaville: Paris suburbs at night' series, 2015-2018. Rémy Soubanère © 2015/18

p.15 Markku Lähdesmäki, *Untitled*, from the 'Avanto – Hole in the Ice' series, 2015. © Markku Lähdesmäki (www.markkuphoto.com)

p.17 Tine Poppe, *Untitled*, from the 'Winter Solstice' series, 2017 © Tine Poppe

p.19 Isabella La Rocca González, *Untitled*, from the 'Fast Food' series, 2013. © Isabella La Rocca González

p.21 Guido Paulussen, *Untitled*, from the 'Medical Waiting Rooms' series, 2017. © Guido Paulussen

p.23 Nadav Kander, *Interruption I*, from 'The Parade' series, 2002 © Nadav Kander

p.25 Doug DuBois, *Shauna, Patrick and Corey, Cobh, Ireland*, 2012, from 'My Last Day at Seventeen' (New York: Aperture, 2015). © Doug DuBois

p.27 Margherita and Nick Burns, *Famadihana ceremony, Madagascar*, 2015. Photo © Margherita and Nick Burns (www.thecrowdedplanet.com)

p.29 Comedian Dave Chappelle at The World Famous Comedy Store, Sunset Boulevard, Santa Monica, California, 2014. Photo WENN Rights Ltd/Alamy Stock Photo

p.31 Elise Corten, *Self-Portrait With Mother*, from the 'Warmer Than the Sun' series, 2019. © Elise Corten

p.33 Kurt Simonson, *Veranda (Swedish Light)*, from the 'A Thin Silence' series, 2011. © Kurt Simonson

p.35 Fabio Moscatelli, *Arriving-Somewhere_3*, from the 'Arriving Somewhere Not Here' series, 2013. © Fabio Moscatelli

p.37 Catherine Balet, from the 'Strangers in the Light' series, 2009. © Catherine Balet

p.39 Jakob Lederlein, Family tree of Louis III, Duke of Württemberg (ruler, 1568-1593). Landesmuseum Württemberg. Photo © Landesmuseum Württemberg, P. Frankenstein/H. Zwietasch

p.41 Saul Robbins, *Upper West Side*, 2008 (17110817), from the 'Initial Intake' series. © Saul Robbins

p.43 One of ten Rorschach inkblot test cards in a cardboard case, printed by Hans Huber, Bern, Switzerland, 1921–1950. This example was used at the Institute of Education, Department of Psychology, between 1960 and 1990. Photo © Science Museum/Science & Society Picture Library – All rights reserved

p.45 Alena Kakhanovich, *The Long Time*, from the 'Sleeping Garden' series, Minsk, Belarus, 2018. © Alena Kakhanovich

p.47 David Hockney, *21st May 2020*, 2020. iPad painting printed on paper, edition of 10, 69.9 x 91.4 cm. © David Hockney

p.49 A man receives a cup of ayahuasca, traditional Amazonian plant medicine used for visionary healing in a Shipibo maloca in Peru. Photo Brian Van Tighem/Alamy Stock Photo

p.51 Guy Wilkinson, *Suryadarshini*, from the 'Meditation' series, 2017. © Guy Wilkinson (guywilkinson.photography)

p.53 Radek Kalhous, *ZOO Liberec/3.12.2015*, from the 'Wilderness' series, 2015. © Radek Kalhous

p.55 Margaret Mitchell, *Leah in Her Living Room*, from the 'In This Place' series, 2016–2017. © Margaret Mitchell

p.57 Hellen Van Meene, *Untitled nr.063*, 1999. © Hellen Van Meene

p.59 Vanja Bucan, *Untitled*, from the 'Anatomy of False Memories' series, 2015. © Vanja Bucan

p.61 Christopher Dawson, *Britney Spears, Los Angeles, California*, from the 'Coverage' series, 2008. © Christopher Dawson

p.63 Álvaro Hoppe, *Calle Alameda, Santiago de Chile*, 1983. © Álvaro Hoppe, courtesy of the artist

p.65 Barbara Peacock, *Claire & Tee, 'We Are Colorblind', Detroit*, from the book 'American Bedroom', published by Kehrer Verlag, 2023. © Barbara Peacock 2023

p.67 Matty Benedetto, *The Baguette Pack™*, from 'Unnecessary Inventions', 2019. Photo Matty Benedetto/ unnecessaryinventions.com

p.69 Nik Erik Neubauer, *Kavarna Union Cafe, Ljubljana*, 25th April 2015. © Nik Erik Neubauer

p.71 Cy Twombly, *Untitled*, 1968. Oil-based house paint and wax crayon on canvas, 172.7 x 228.6 cm. Private Collection. Photo courtesy of Sotheby's. © Cy Twombly Foundation

p.73 Laetitia Vancon, *Landscape on Lewis Island, Uig*, from the 'At the End of the Day – *Aig deireadh an latha*' series, 2016. © Laetitia Vancon

p.75 Tabitha Barnard, *Clot*, from the 'Cult of Womanhood' series, 2018. © Tabitha Barnard

p.77 Rod Taylor in *The Time Machine*, 1960. Photo Moviestore Collection Ltd/Alamy Stock Photo

p.79 Dougie Wallace, *Untitled*, from the 'Harrodsburg' series, 2018. © Dougie Wallace

p.81 Kiran Anklekar, Hindu man meditating. Photo Kiran Anklekar/Unsplash.com

p.83 Alex Crétey Systermans, *Sidonie, Paris, 2012*, from the 'Familiar' series, 2012 © Alex Crétey Systermans

p.85 Edgar Degas, *Dans un café (Absinthe)*, 1875–1876. Oil on canvas, 92 x 68.5 cm. Musée d'Orsay, Paris. Photo Adrien Didierjean. RMN-Grand Palais/Dist. Photo SCALA, Florence

p.87 Alfred Sisley, *Winter Landscape, Moret*, c. 1888. Pastel on paper, 38 x 55.4 cm. Von der Heydt-Museum Wuppertal, Inv. No. G 0994. Photo Medienzentrum Wuppertal

p.89 Vicenzo Foppa, *The Young Cicero Reading*, c. 1464. Fresco transferred to canvas mounted on panel, 101.6 x 143.7 cm. The Wallace Collection, London. Photo © Wallace Collection, London, UK/Bridgeman Images

Also available from The School of Life:

Confidence in 40 Images
The art of self-belief

An inspiring curated selection of 40 photographs and artworks with accompanying essays examining the skill of confidence.

The difference between success and failure often comes down to an ingredient that we are seldom directly taught about and may forget to focus on: confidence.

What makes one life cheerful, purposeful and energetic and another less so may have nothing to do with intelligence or qualifications; it may simply be bound up with that buoyancy of the heart and mind we call confidence – the quality that gives us the courage to give things a go, to believe in ourselves and to resist the pull of conformity, fear and despair.

Here is a supreme guide to this fatefully neglected quality; a series of encouraging essays that jog us into a new and more fruitful state of mind. The images that accompany the text are there to ensure that we aren't merely intellectually stirred to change our lives, but that we are also given the best kind of visual assistance.

Although modest in size, this book succeeds at a mighty feat: unlocking our latent powers and edging us on with kindness and creativity to become the best version of ourselves.

ISBN: 978-1-915087-30-0

A Therapeutic Atlas
Destinations to inspire and enchant

ISBN: 978-1-912891-93-1

A selection of unique and beautiful destinations around the world, which offer powerful new perspectives on life.

The world is full of places with an unusual power to inspire and bring us joy; they might be exceptionally beautiful, resonant with history, untouched by civilisation or rich in the right sort of memories.

This is an atlas that gathers together some of the most enchanting and re-invigorating places around the world in order to heal and captivate us. A perfect book for keen travellers, it takes us to beautiful destinations in Greece, Italy, Japan, America, Chile and Australia – to name but a few. We're taken to the tops of mountains, solitary cliffs, elegant cities – and also to some less expected locations: airports, hydroelectric stations and meteorite craters.

Great travellers have always known that travelling can broaden the mind; here we see how it can also heal it. Tempting images are combined with short essays that discuss the power of particular places to help us with the difficulties of being human.

This is a book that can be read when we are travelling or when we are at home; it will remind us of the many places we still want to see – and, more broadly, the many reasons we have to stay hopeful.

The School of Life publishes a range of books on essential topics in psychological and emotional life, including relationships, parenting, friendship, careers and fulfilment. The aim is always to help us to understand ourselves better – and thereby to grow calmer, less confused and more purposeful. Discover our full range of titles, including books for children, here:

www.theschooloflife.com/books

The School of Life also offers a comprehensive therapy service, which complements, and draws upon, our published works:

www.theschooloflife.com/therapy

THESCHOOLOFLIFE.COM